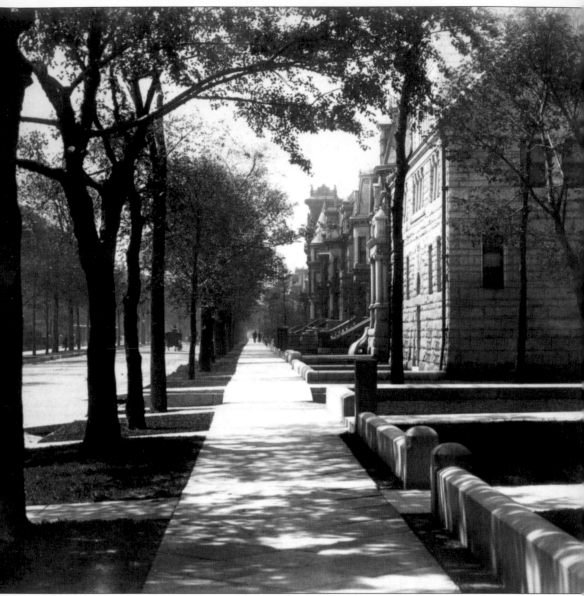

Noted photographer J. W. Taylor took this view of Prairie Avenue looking south at Eighteenth Street in the 1890s. It was reproduced and widely distributed as a hand-tinted postcard, thus becoming an easily recognizable image of the avenue. In the foreground is the home of John and Frances Glessner, which now operates as a house museum, interpreting life on Prairie Avenue in the late 19th century.

On the cover: This is the east side of Prairie Avenue, looking north from Twentieth Street (now Cullerton Street) around 1888. At the center of the image is the home of retail giant Marshall Field, Chicago's wealthiest citizen in the 19th century. The home to its right was later purchased by Marshall Field Jr. and today is one of only 11 original houses remaining in the neighborhood. (Photograph by George M. Glessner, courtesy of Glessner House Museum.)

IMAGES
of America

CHICAGO'S HISTORIC PRAIRIE AVENUE

William H. Tyre

ARCADIA
PUBLISHING

Published by Arcadia Publishing
Charleston SC, Chicago IL, Portsmouth NH, San Francisco CA

Printed in the United States of America

Library of Congress Catalog Card Number: 2008920509

For all general information contact Arcadia Publishing at:
Telephone 843-853-2070
Fax 843-853-0044
E-mail sales@arcadiapublishing.com
For customer service and orders:
Toll-Free 1-888-313-2665

Visit us on the Internet at www.arcadiapublishing.com

*This volume is gratefully dedicated to Addie Hibbard Gregory,
the Glessner family, and other residents who recorded the fascinating
history of Prairie Avenue in words and photographs
for future generations to enjoy.*

CONTENTS

ACKNOWLEDGMENTS

The first person due thanks is Jethro Meriwether Hurt III, former curator at the Glessner House Museum, who oversaw the creation of a series of interpretive panels along the 1800 block of Prairie Avenue in the late 1970s. When I saw these panels on my first visit to the street in June 1981, I was hooked, and my journey began. Robert Pruter's master's thesis on the decline of Prairie Avenue was a valuable tool in understanding the transformation of the street in the early 1900s. Mary Alice Molloy's writings, including *Prairie Avenue Servants* and a wonderful chapter in the *Grand American Avenue*, heightened my curiosity and encouraged me to continue my research. Allan Vagner, Jack Simmerling, and Bob Irving all shared wonderful stories with such detail that I almost felt they had witnessed the events firsthand.

Although the majority of the images in the book came from either my personal collection or the archives of the Glessner House Museum, nearly 40 percent came from other collections. I especially wish to thank Ward Miller of the Richard Nickel Committee for his enthusiastic support and Richard Seidel for his great assistance as both the archivist for the Episcopal Diocese of Chicago and the Chicago Board of Education. Mary Woolever of the Ryerson and Burnham libraries at the Art Institute of Chicago was an amazing resource. Rob Medina and the research library staff at the Chicago History Museum were incredibly helpful. Several descendants of early Prairie Avenue families were most gracious in opening their personal archives, including Albert Beveridge III, Susan and Claudia Clifford, Barbi Donnelley, Bennet B. Harvey, Cristy Laier, Elliott Otis, Cynthia Richardson, Barry Sears, and Linda Williamson. Special thanks go to Rena Appel, Wendy Bidstrup, Robert Furhoff, Janice Hack, Ed Hirschland, Joy Kingsolver, Kim Lindstrom, John K. Notz Jr., Pauline Saliga, Linda Smith, Terry Tatum, John Vinci, and Peter Wild. Lastly, deep appreciation goes to friends and family who supported me through the long process of gathering images and never tired of listening to yet another story of Prairie Avenue, including my parents, Roger and Charlotte Tyre; Heather Plaza-Manning; Will Smith; Tina Strauss; and Laurie Toth.

All photographs and illustrations are from the collection of the author or the Glessner House Museum, except as noted.

INTRODUCTION

Chicago's historic Prairie Avenue is more than just a street or a neighborhood. Known by such lofty names as "the sunny street of the sifted few," and "the residence street par excellence," Prairie Avenue achieved a prominence in the late 19th century that will probably never again be achieved in Chicago. The residents of the street were largely self-made men who amassed their fortunes establishing businesses that shaped Chicago and frequently impacted the national economy. In so doing, they literally put Chicago on the map, rebuilding it at an astonishing rate following the Chicago Fire and winning for it the honor of hosting a world's fair in 1893.

Prairie Avenue runs from Sixteenth Street south to the city limits, but the concentration of this volume is only the first six blocks, from Sixteenth Street to Cermak Road (originally Twenty-second Street). That was the section referred to in newspapers as the "richest half-dozen block in Chicago," and what guidebooks urged visitors to see while visiting the city. Geographic considerations changed the character of the thoroughfare south of Twenty-second Street, but another section, sometimes referred to as "lower Prairie Avenue," reappeared at Twenty-sixth Street and continued for another five blocks. That area will be examined briefly, as will the adjacent north–south streets of Calumet, Indiana, and Michigan Avenues that comprised the neighborhood north of Twenty-second Street.

As was the case with the evolution of most major cities, this prominent residential section developed near the downtown core, providing business leaders with quick and easy transportation to their offices. In Chicago, the south side was chosen because it did not require the crossing of a branch of the Chicago River, a factor that delayed the development of a comparable area to the north. Homer Hoyt, in his *One Hundred Years of Land Values in Chicago,* explained the successful development of the area by Chicago's leading citizens when he stated, "The values of land along streets made exclusive through their occupancy by the leaders of society is a direct reflection of the rise of a newly rich class during and after the Civil War . . . who had an ambition to live in mansions amid fashionable surroundings." The neighborhood that resulted was beautiful—large, elegant homes designed by the leading architects of the day. Daniel Hudson Burnham and John Wellborn Root designed some of the most distinctive residences and received the most commissions, possibly due to the fact that both men married into Prairie Avenue society and lived for a time on the street. Early architects, including John M. Van Osdel, William W. Boyington, and William Le Baron Jenney all designed homes on the street, and by the 1880s, firms such as Cobb and Frost and Treat and Foltz were adding their designs as well. A few architects outside of Chicago received commissions, including Richard Morris Hunt, Arthur Little, and Henry Hobson Richardson, whose design for the Glessner house is

considered a pivotal work in the movement toward modern architecture. Inside the houses were filled with costly furnishings collected during trips abroad, and the walls were hung with valuable works of art. A constant variety of social activities—from teas and concerts to balls and weddings—received extensive coverage in the society pages. In spite of the heights that the area achieved, the glory days started to draw to a close in a mere 30 years. By the early 1900s, the push of business beyond the downtown area and the opening of new, affluent residential districts resulted in Prairie Avenue quickly falling from favor. Older residents often chose to live out their lives here, but their children moved away, leaving behind homes that were converted to business use, chopped up into furnished rooms, boarded up, or demolished. Additional transportation routes were cut through the neighborhood, and the increased traffic and pollution from the nearby Illinois Central Railroad made it virtually impossible for even the trees to survive. The infamous vice district known as the Levee established itself just a few blocks to the west, and increased crime resulted in the need for the remaining residents to hire private security for the street.

The neighborhood's second life was characterized by the appearance of loft buildings, many for the printing and publishing industries. The lack of a comprehensive zoning ordinance prior to 1923 allowed developers to simply tear down a house and put up a building for business use, leaving the adjacent residences in the shadows to endure the noise and traffic. Michigan Avenue fell the fastest of all, the victim of its own beautiful pavement that attracted more than 130 automobile dealers to build their showrooms along its path. Prairie Avenue witnessed the construction of its first large plant in 1916, built to manufacture hairpins. When Chicago did enact its zoning ordinance in 1923, a picture of the hairpin plant was included as an example of why zoning was so important. But it was too late for Prairie Avenue—the entire neighborhood was zoned for light manufacturing. A few residents still remained, determined to stay in their homes until the very end. In 1944, Addie Hibbard Gregory, who had resided on the street for 77 years, finally abandoned her beloved Prairie Avenue home and had it razed. The last resident was gone.

The threatened demolition of the Glessner house in the mid-1960s brought renewed attention to the area. The Chicago School of Architecture Foundation was formed to purchase the house in 1966, the same year that the National Historic Preservation Act was passed. A new awareness of Chicago's rich architectural heritage was awakening. When three of the few remaining residences on Prairie Avenue were razed by 1968, talk of preserving the surviving homes began. A unique public-private partnership studied the concept of creating a historic district, something that the city had never done before. It was not an easy sell; the few homes that remained were scattered along four blocks interspersed with vacant lots, loft buildings, and parking lots. The National Park Service listed the area on the National Register of Historic Places in 1972, but this did nothing to protect the houses, including three more that were threatened when they were put up for sale the previous year. Finally in 1973, Mayor Richard J. Daley held a press conference to announce the city's plan to create the first historic district in Chicago. Funds provided by the state and city were used to acquire many of the vacant properties. The streetscape on the 1800 block of Prairie Avenue was restored to its 1890s appearance, and the historic Clarke house was acquired by the city and moved to the 1800 block of Indiana Avenue. Formal designation of the district occurred in 1979.

The 1990s saw the rebirth of the area, as residential development spread south from the highly successful Central Station, where Mayor Richard M. Daley had moved in 1993. Loft buildings were converted to condominiums, and townhomes and high-rises sprang up along the streets. Gregory's prophecy, made shortly before she left the street in 1944 had come true. She said, "In time, I am certain, old Prairie Avenue will come into its own again, when there is intelligent planning for those employed in or near the center of our business district."

One

A NEIGHBORHOOD IS ESTABLISHED

The history of the neighborhood begins more than 20 years before its first settler arrived. On August 15, 1812, during the war with Great Britain, a band of 95 soldiers and civilians were ordered to evacuate Fort Dearborn for the safety of Fort Wayne in Indiana. Upon reaching the area in the general vicinity of Eighteenth Street and Prairie Avenue, the band was attacked by Native Americans sympathetic to the British. Over 50 members of the party perished in the brief battle, which came to be known as the Fort Dearborn massacre. The bodies of those killed laid undisturbed for four years until the fort was rebuilt in 1816. A stately cottonwood tree and later a monumental bronze statue marked the site for over 100 years, making it Chicago's first true landmark. Today the event is viewed with an understanding of the Native American's struggle to hold onto their lands, and the term *massacre* is used only in its historical context.

Development of the neighborhood began in 1833 with the acquisition of 138 acres of land by Dr. Elijah D. Harmon, who built the first house here but left soon after. Henry B. Clarke acquired a portion of the land and the log cabin, and in 1836, he completed a Greek Revival home that survives today as Chicago's oldest building. In the early 1850s, the area was subdivided and the present north south streets were platted and named. John Staples completed the first house on Prairie Avenue in 1853, but only a few others were built by the time of the Civil War. The late 1860s saw a building boom, with dozens of homes completed or underway by the time of the Great Chicago Fire in 1871, which bypassed the neighborhood. Prior to the fire, George M. Pullman and Marshall Field both acquired land on the street upon which to build their homes. Those purchases, together with the completion of Daniel Thompson's house at 1936 South Prairie Avenue, reportedly the most expensive house in the city up to that time, secured Prairie Avenue's prominence as the premier residential street in Chicago.

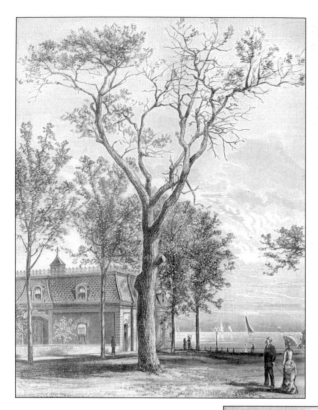

This cottonwood tree, located on Eighteenth Street between Prairie and Calumet Avenues, was identified as marking the site of the Fort Dearborn massacre by early Chicago resident Fernando Jones, who visited the site in the 1830s with a Native American that had participated in the battle. Jones, who later resided at 1834 South Prairie Avenue, hung a warning sign on it that read, "Cursed be he that removeth the ancient landmarks."

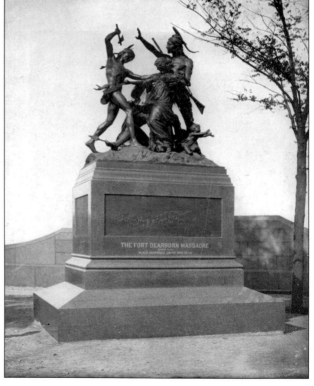

George M. Pullman commissioned sculptor Carl Rohl-Smith to design this bronze grouping that depicts Black Partridge rescuing Margaret Helm during the Fort Dearborn massacre. The sculpture, with its base, stood 19 feet high and was located on the north side of Eighteenth Street at Calumet Avenue. It was unveiled on June 22, 1893, with the dedicatory oration being given by former president Benjamin Harrison. It was moved to the Chicago Historical Society in 1931.

The venerable massacre tree died in the late 1880s but remained standing until it was felled during a windstorm on May 18, 1894. Souvenir hunters swarmed the site to retrieve a piece of the relic, but the main section of the trunk was salvaged by George M. Pullman and given to the Chicago Historical Society. Pullman's stable is visible to the left of the tree in this image taken about 1888.

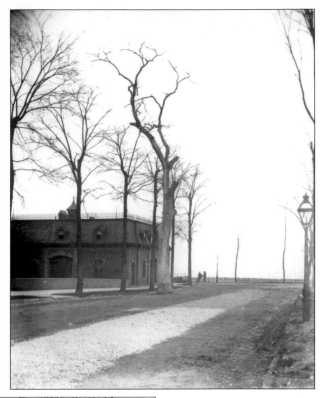

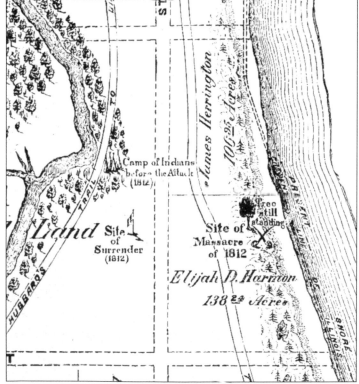

In 1833, Dr. Elijah D. Harmon, who is credited with performing the first surgical operation in Chicago, acquired by preemption 138 acres of land bounded by present day Sixteenth Street to the north, Cermak Road to the south, State Street to the west, and Lake Michigan to the east. To secure his claim, he built a log cabin on the property but remained only one year before moving to Texas.

11

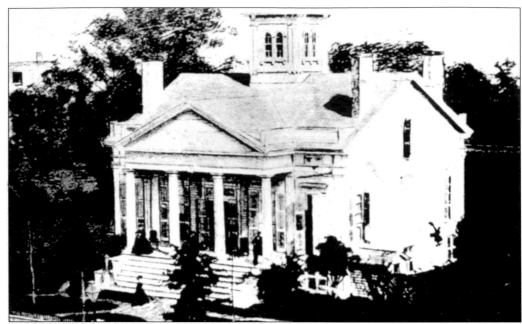

Henry B. Clarke purchased 20 acres of land from Dr. Elijah D. Harmon in 1835 and moved into his cabin. The following year, Clarke built this substantial timber-frame Greek Revival home near present-day Michigan Avenue south of Sixteenth Street. Clarke died in the cholera epidemic of 1849, and his widow, Caroline, subdivided their property, using the proceeds to complete the home. The house has been moved twice and now stands at 1827 South Indiana Avenue. (Courtesy of the Chicago History Museum.)

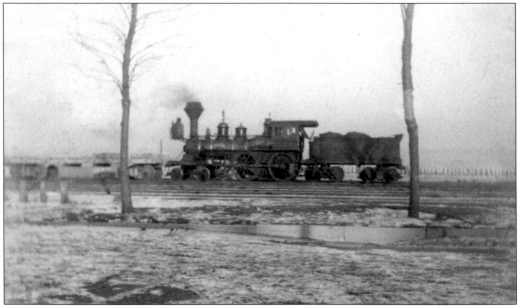

In 1852, the Illinois Central Railroad was granted rights to build a trestle along the Lake Michigan shoreline in exchange for building a stone breakwater to curb erosion. By 1856, the railroad was making three round trips per day to Hyde Park. This view, taken about 1888, shows an Illinois Central engine standing near the foot of Eighteenth Street.

The first house built on Prairie Avenue was completed in 1853 for brick manufacturer John Staples at 1702 South Prairie Avenue. The Italian villa–style home had an unobstructed view of the lakeshore, which was located about 250 feet to the east. Staples's daughter married John Shortall, and four generations of the family lived on the street. The house was extensively remodeled in the 1880s (see page 32). (Courtesy of the Chicago History Museum.)

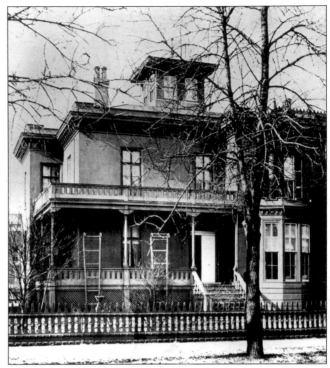

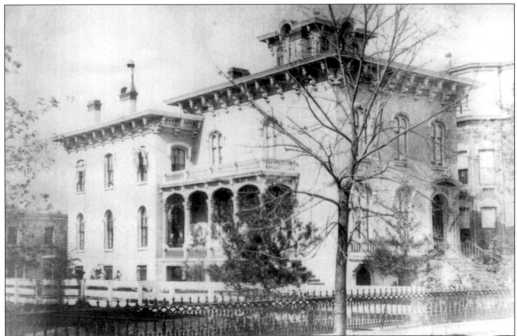

Another early house on the street was built in 1857 at 1824 South Prairie Avenue for Samuel B. Pomeroy, a produce commission merchant and onetime vice president of the Chicago Board of Trade. The Italianate-style home was later owned by Henry W. Hinsdale and James A. Smith before receiving a new facade by George B. Marsh in the 1880s (see page 32). (Courtesy of Cynthia Richardson.)

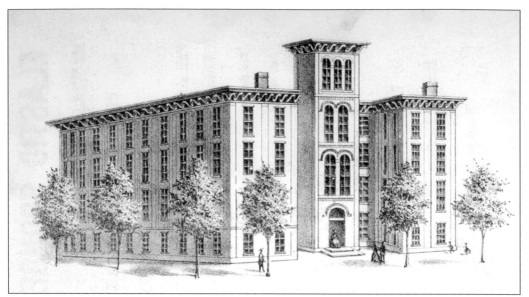

The Chicago Orphan Asylum was organized in 1849 following a devastating cholera outbreak. In 1854, the asylum completed this building at 2228 South Michigan Avenue. By the time the institution moved to larger facilities at South Park Avenue and Fifty-first Street in May 1899, it was estimated that more than 6,000 children had found care and shelter in this building.

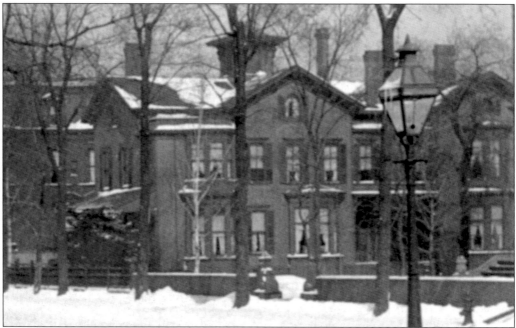

Attorney Wirt Dexter completed his home at 1721 South Prairie Avenue in 1863. It was one of a small number of frame structures ever built on the street. Dexter held the important position of chair of the executive committee of the Chicago Relief and Aid Society following the Chicago Fire. He later commissioned a large addition to the front of his house (see page 40).

14

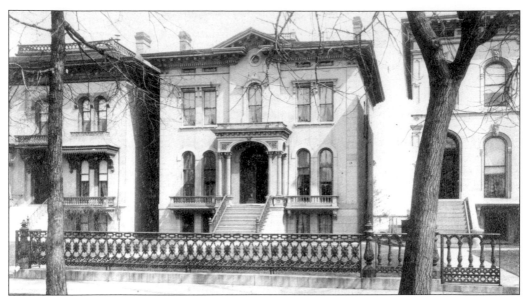

John A. Logan, a celebrated Union general during the Civil War, resided in this home at 2119 South Calumet Avenue. He served in the U.S. House of Representatives and U.S. Senate, ran unsuccessfully for vice president in 1884, and issued the order for the first nationwide Decoration Day in 1868 as commander-in-chief of the Grand Army of the Republic. The house was extensively remodeled by a later owner (see page 54). (Courtesy of the Chicago History Museum.)

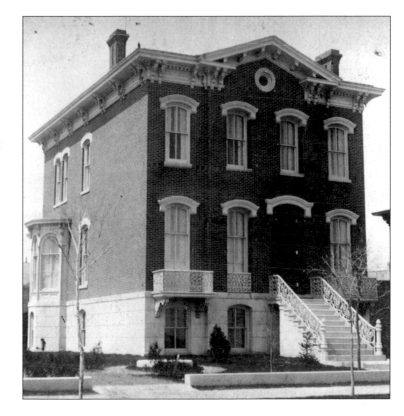

The house at 1834 South Prairie Avenue was designed for Chicago pioneer Fernando Jones in 1866 by Chicago's first professional architect, John M. Van Osdel. Jones was the head of the abstract firm of Fernando Jones and Company, which merged with other firms in 1877 to form the Chicago Title and Trust Company. The residence was later significantly enlarged and remodeled by Jones (see page 39). (Courtesy of the Chicago History Museum.)

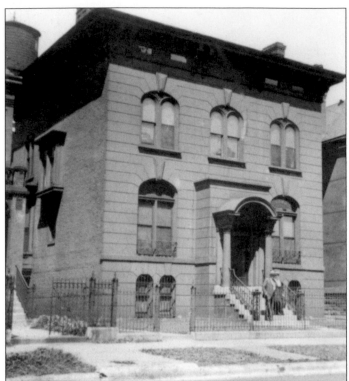

Completed in 1868 for Joseph Goodman, this home at 1612 South Prairie Avenue was typical of post–Civil War construction, with its smooth limestone facade, tall arched windows, and bracketed cornice. For many years, it was home to a member of the Studebaker family, makers of carriages and later automobiles. From 1905 until 1922, it served as the official residence of Charles P. Anderson, Episcopal bishop of Chicago. (Courtesy of Archives and Historical Collections, Episcopal Diocese of Chicago.)

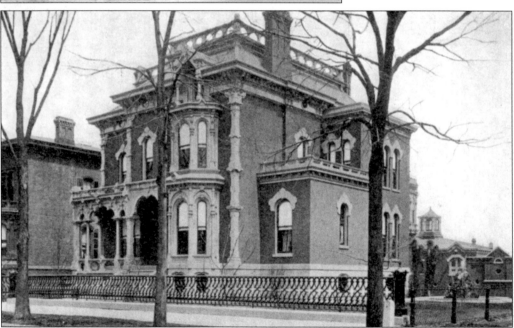

William G. Hibbard commissioned noted architect William Le Baron Jenney to design his home at 1701 South Prairie Avenue in 1868. Hibbard was president of the wholesale hardware firm of Hibbard, Spencer, Bartlett and Company. In 1921, the house was sold to the American Terra Cotta Company, which provided free office space here to architect Louis H. Sullivan until his death in 1924. The house was razed in 1932.

Architect John W. Roberts designed the home at 1638 South Prairie Avenue in the Hudson River Gothic style for John G. Shortall in 1868. In 1880, the home was purchased by William G. Hibbard and presented to his daughter Addie upon her marriage to Robert B. Gregory, who became president of Lyon and Healy Company. She lived here for 64 years until it was demolished in 1944. (Courtesy of the Clifford family.)

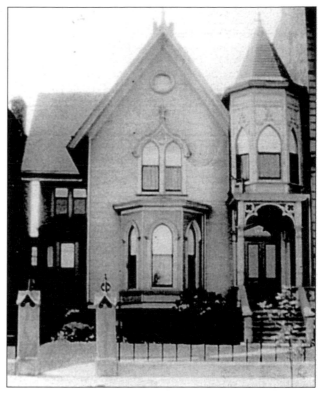

This grouping of marble-front row houses at 2031–2035 South Prairie Avenue was built in 1869 using limestone known at the time as Athens marble. The homes were purchased by Samuel Tolman, Frederick Otis, and Horatio Stone, respectively. Oscar Wilde was entertained in the Stone house during his Chicago visit in 1882. The three houses were razed in the 1940s. See page 111 for a view of 2033 South Prairie Avenue prior to demolition.

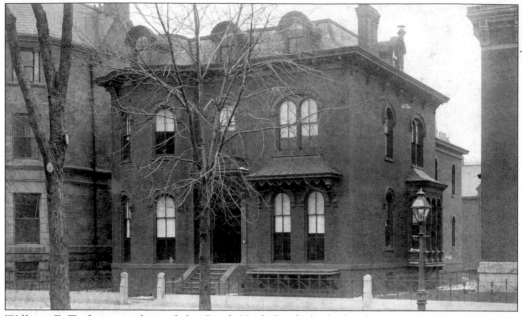

William F. Tucker, president of the Stock Yards Bank, built this home at 2126 South Prairie Avenue in the late 1860s. In 1877, he sold the house to Charles D. Hamill, onetime president of the Chicago Board of Trade. Hamill was a lifelong trustee and major supporter of the Chicago Symphony Orchestra. The house was rebuilt by a subsequent owner (see page 48).

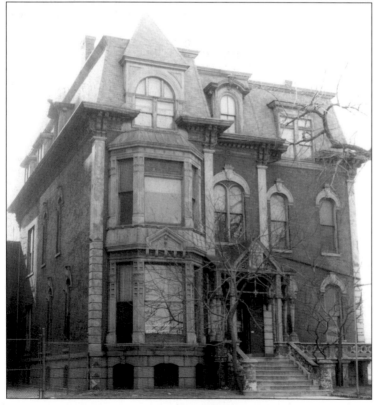

Banker Calvin T. Wheeler commissioned architect Otis L. Wheelock to design this Second Empire–style house at 2018 South Calumet Avenue in 1870. In 1874, the home was purchased by wholesale clothier Joseph A. Kohn and his family remained until the early 1900s. This 1950s view shows the house converted into a warehouse for the Murphy Butter and Egg Company. It is the last surviving residence on Calumet Avenue. (Courtesy of the Chicago History Museum.)

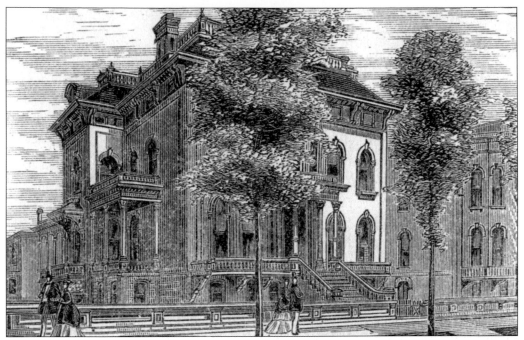

Edson Keith moved into this home at 1906 South Prairie Avenue in 1870. Severe headaches drove Keith to commit suicide in 1896 by throwing himself into nearby Lake Michigan. In 1898, his son Walter divided the house vertically into two residences, adding a second ground-level entrance at the north end. By 1920, it functioned as a Presbyterian women's boardinghouse known as the Esther Club. It was razed in 1942.

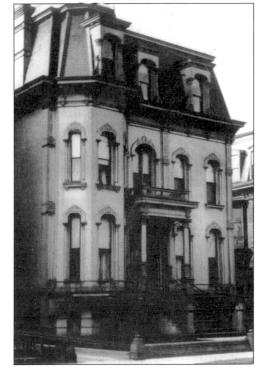

Elbridge Keith hired John W. Roberts to design this house at 1900 South Prairie Avenue in 1870. Elbridge was a partner with his brother Edson in the family millinery business but later served as president of the Metropolitan National Bank, the forerunner to the First National Bank of Chicago. The structure housed the Prairie Avenue Bookshop from 1974 to 1978, at which point it reverted back to residential use.

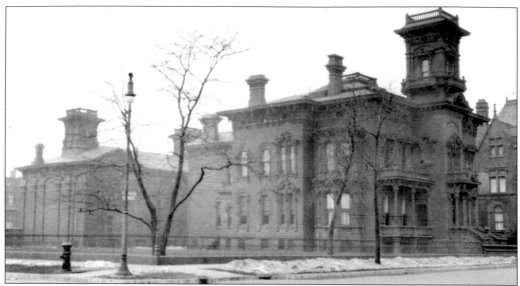

Architect Lavall B. Dixon built this imposing home at 1936 South Prairie Avenue in 1869 and 1870 for Daniel Thompson, superintendent of the Chicago City Railway. The 75-foot tower made the residence the tallest on the street, and its 193 feet of frontage along Prairie Avenue made it the largest single piece of property. The $100,000 cost was said to be the most paid up to that point for any house in Chicago. (Courtesy of the Chicago History Museum.)

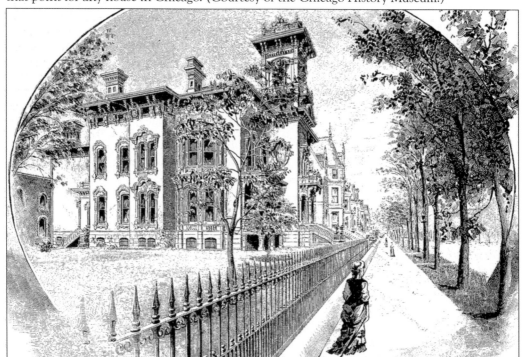

In 1879, the house was purchased by Samuel W. Allerton, who, along with John B. Sherman, is credited with the opening of the Chicago Union Stock Yards in 1865. He was one of the organizers of the First National Bank, introduced cable cars into the city, and ran unsuccessfully for mayor against Carter Harrison in 1893. He died in 1914, and the house was razed the following year.

Two

THE GLORY DAYS OF PRAIRIE AVENUE

The years immediately following the Chicago Fire saw a tremendous building boom in the neighborhood as citizens burned out of their homes elsewhere sought to rebuild here. The arrival of Philip D. Armour on Prairie Avenue in 1877 resulted in Chicago's three wealthiest citizens—Marshall Field, Armour, and George M. Pullman, in that order—living within a four-block stretch of the street. Leading architects of the day were hired to design elegant free-standing and attached houses for Chicago's business and social leaders. Burnham and Root, whose second commission ever was for the John B. Sherman house at 2100 South Prairie Avenue, designed more than a dozen projects. Other Chicago architects commissioned to design houses on the street included John M. Van Osdel, William Le Baron Jenney, Solon S. Beman, Treat and Foltz, Cobb and Frost, and Francis M. Whitehouse. Richard Morris Hunt of New York and Henry Hobson Richardson of Boston were among the few outside architects to receive commissions. The predominant architectural styles in the 1870s and 1880s were all based on French precedent, with the Second Empire style and its tall mansard roof the most common of all. From the mid-1880s onward, the rugged Romanesque style and the revival styles made popular by the World's Columbian Exposition reigned in popularity.

Prairie Avenue became the center of Chicago's social scene, with balls, dinners, and concerts reported regularly in the society pages. To operate the households and stage these events, a typical household employed at least four to six live-in servants, usually recently arrived European immigrants. Summer saw the street largely abandoned however, as most residents left the heat of the city for their summer homes or traveled to Europe for sightseeing and to purchase the latest fashions and objets d'art.

By the time of the World's Columbian Exposition in 1893, the avenue was publicized as a must-see attraction for visitors coming into the city. A Rand McNally and Company guidebook stated, "That remarkable street is home to merchants whose business affects every mart on the earth . . . and who possess wealth that at last aroused the jealousy of New York."

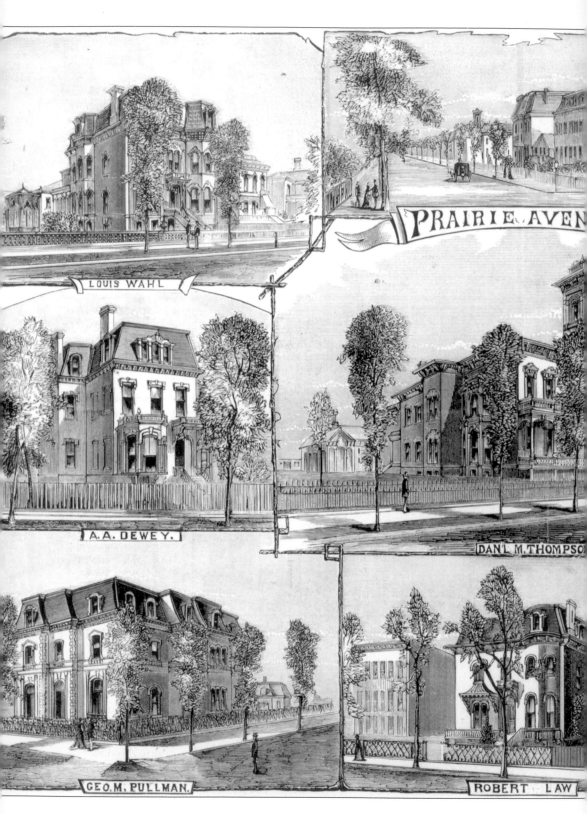

PRAIRIE AVEN

LOUIS WAHL

A. A. DEWEY.

DAN'L M. THOMPSO

GEO. M. PULLMAN.

ROBERT LAW

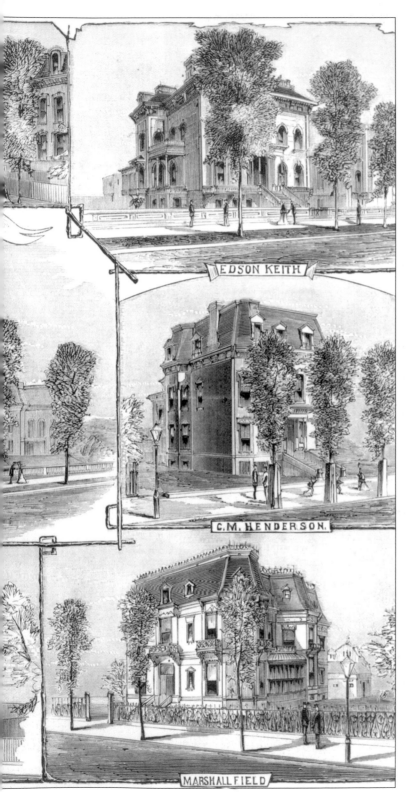

EDSON KEITH

C.M. HENDERSON.

MARSHALL FIELD.

This montage of Prairie Avenue homes appeared in the May 1874 issue of the *Land Owner*. The text referred to the street as "one of the most fashionable and handsomely-built of all our South-Side thoroughfares." It went on to encourage readers to visit streets such as Prairie Avenue for "one of the greatest attractions a city can offer is its homes, for to obtain them is the end of most men's aspirations." The homes pictured clockwise from the upper left are 2026 South Prairie Avenue, home of Louis Wahl; west side of Prairie Avenue looking south from Eighteenth Street; 1906 South Prairie Avenue, home of Edson Keith; 1816 South Prairie Avenue, home of Charles M. Henderson; 1905 South Prairie Avenue, home of Marshall Field; 1620 South Prairie Avenue, home of Robert Law; 1729 South Prairie Avenue, home of George M. Pullman; 1730 South Prairie Avenue, home of A. A. Dewey; and 1936 South Prairie Avenue, home of Daniel M. Thompson. All have been demolished.

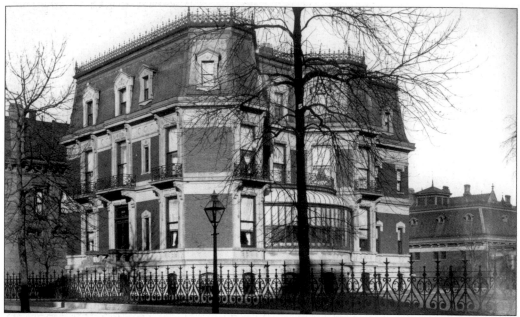

Retail giant Marshall Field commissioned New York architect Richard Morris Hunt to design his home at 1905 South Prairie Avenue. The construction began in 1871 and was completed two years later. The most prominent elevation featured a broad, curved conservatory that faced south into the large side yard. The property passed to Field's second wife, Delia, upon his death in 1906, but she rarely lived here, choosing instead Washington, D. C., for her home.

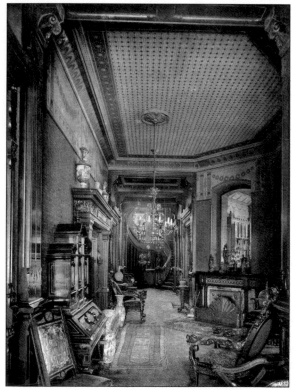

The plan of the house featured a long central hall that led back to a dramatic winding staircase. The two rooms located to the right flanked the central conservatory and were octagonal in shape, as indicated by the angled fireplace walls. The interior was dramatically remodeled when the house was later converted into a design school (see page 109). It was demolished in 1955. (Courtesy of the Art Institute of Chicago, Ryerson and Burnham Archives, Historic Architecture and Landscape Image Collection.)

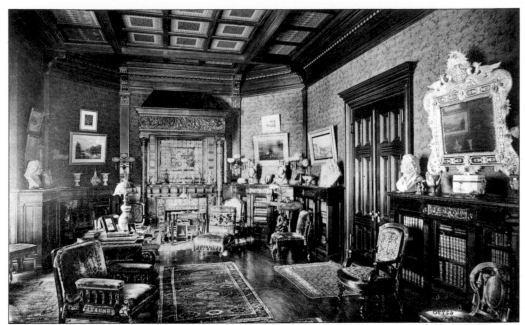

The largest room in the Marshall Field house was the drawing room, which featured an elaborate coffered ceiling and a lovely stained-glass window over the fireplace mantel. The house was one of only two Chicago residences featured in the 1883 volume *Artistic Houses*, which showcased nearly 100 of the finest residences in the country. This image and the one preceding are both taken from that publication. (Courtesy of the Art Institute of Chicago, Ryerson and Burnham Archives, Historic Architecture and Landscape Image Collection.)

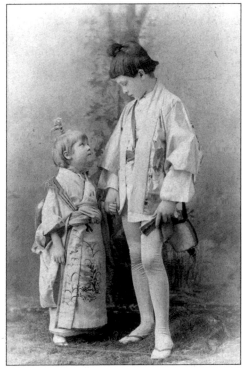

The most celebrated social event ever held on the street was the Mikado Ball held on January 1, 1886, to celebrate the 18th birthday of Marshall Field Jr. The house was transformed into a Japanese village, with Sherry's of New York catering the event and artist James McNeill Whistler designing the party favors. Here Catherine and Spencer Eddy of 1601 South Michigan Avenue are seen dressed for the event. (Courtesy of the Newberry Library, Catherine Eddy Beveridge Papers.)

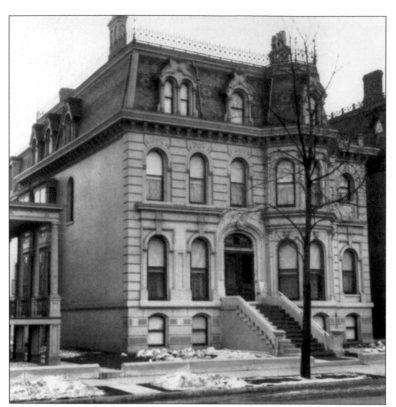

Lumber dealer David Kelley built this Second Empire–style house at 2115 South Prairie Avenue in 1871. Philip D. Armour, one of the nation's leading meat packers, acquired the house in 1877. In 1892, Armour pledged $1 million for the establishment of the Armour Institute of Technology, today known as the Illinois Institute of Technology. See page 110 for a view of the house during demolition. (Courtesy of the Chicago History Museum.)

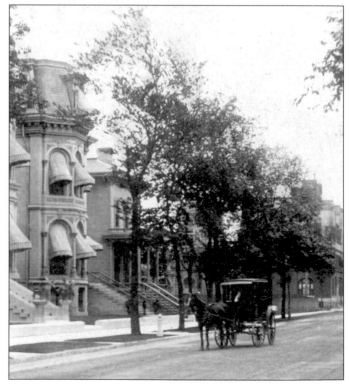

The house at 2123 South Prairie Avenue, shown at left, was built about 1874 for the Getchell family and was acquired by Thomas M. Avery in 1888. Avery founded the Elgin Watch Company in 1867 and served as its president for 25 years until his death in 1901. The home at right, 2125 South Prairie Avenue, was built for Charles H. Wheeler in 1866. He was long associated with the Illinois Central and Rock Island Railroads. Both homes were demolished in the late 1930s.

George Armour, grain elevator owner and president of the Chicago Board of Trade, built his home at 1945 South Prairie Avenue about 1872. In 1879, the Chicago Academy of Fine Arts was organized, and Armour was elected its first president. Three years later, the organization was renamed the Art Institute of Chicago. In 1891, the house was sold to the Colwith family, and it was razed in 1931.

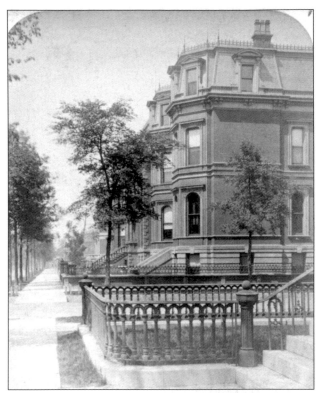

This 1880s view of the 2000 block of Prairie Avenue shows the home of banker Ebenezer Buckingham at far left. Built in 1875 at 2036 South Prairie Avenue, the house contained one of the finest art collections in the neighborhood. It was demolished in 1925. In 1924, Buckingham's daughter Kate made a gift of $385,000 to the South Park Commission for the construction of a fountain in Grant Park to memorialize her brother Clarence, which was completed in 1927.

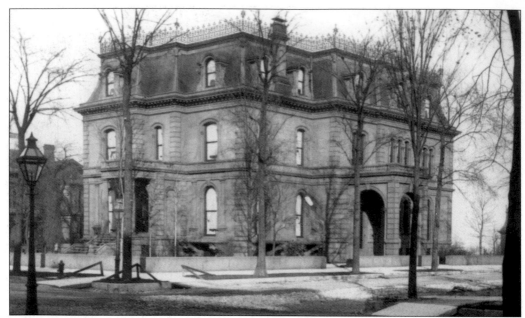

George M. Pullman acquired the property at the northeast corner of Prairie Avenue and Eighteenth Street in 1870, paying $500 per front foot, the highest ever paid in Chicago for a residential lot up to that time. Henry S. Jaffray was commissioned to design the massive brownstone-clad Second Empire–style house with prominent porte cochere facing Eighteenth Street. It was completed in 1876 at 1729 South Prairie Avenue after five years of construction.

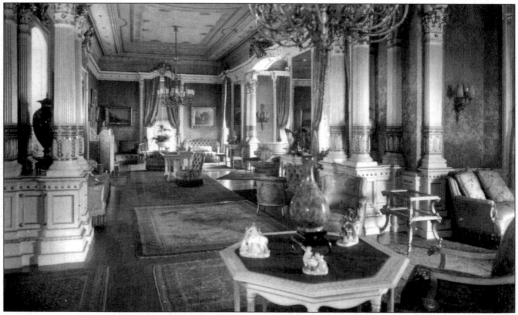

In 1888, the *Chicago Times* said of the Pullman drawing room above, "In point of location, size, and architecture it surpasses any room of its kind in Chicago, whether public or private." Other spaces in the residence included a 200-seat theater, a two-lane bowling alley, and a billiard room. Following Harriet Pullman's death in 1921, the contents were auctioned off for $50,000, and the home was razed the following year. (Courtesy of the Chicago History Museum.)

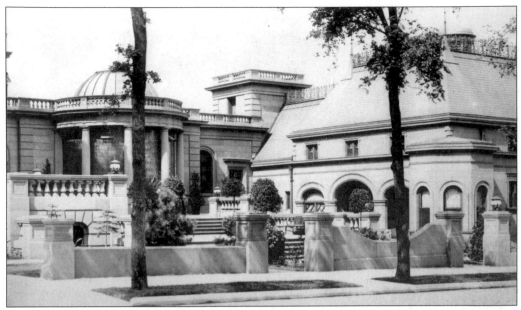

Pullman hired architect Solon S. Beman, who had designed the town of Pullman for him in the early 1880s, to design a series of additions to the house. These included a glass-paned palm court, elaborate terraces, and an enlarged stable at the rear of the property, shown here. Just off the photograph to the right stood the Carl Rohl-Smith-designed statue commemorating the Fort Dearborn massacre.

In 1880, Pullman acquired a series of lots along the west side of Calumet Avenue immediately south of Eighteenth Street. In the early 1890s, he again commissioned Beman to design a string of buildings, including a large conservatory and various other structures that framed the private park and connected to his main property by way of a gracious driveway across Eighteenth Street.

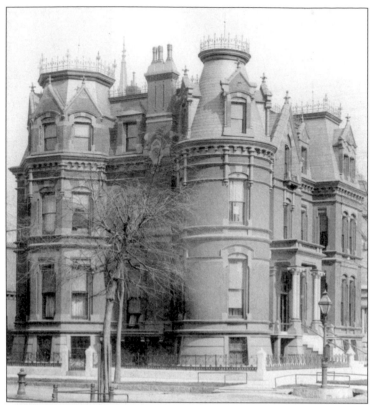

The residence at 2140 South Prairie Avenue, designed by architect John M. Van Osdel in 1876, was completed the following year for William F. Tucker, previously of 2126 South Prairie Avenue. In 1881, Tucker sold the house to Byron L. Smith, who hired Burnham and Root to make various improvements. In 1889, Smith founded the Northern Trust Company and served as its president until his death in 1914.

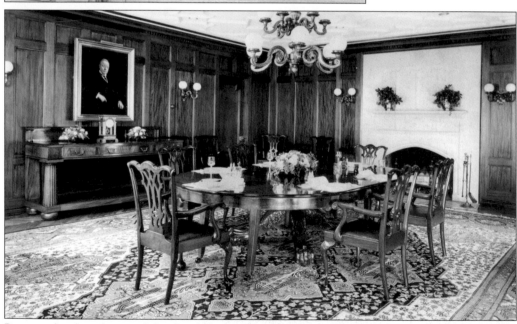

Prior to the demolition of the Smith house in 1936, the family had the dining room carefully dismantled and reassembled as a private dining room at the Northern Trust Company. The furniture was retained as well, with additional chairs being made by Marshall Field to exactly match the originals. The room survives today as the Byron Laflin Smith Guest Dining Room.

The John B. Sherman house at 2100 South Prairie Avenue was the second commission received by the firm of Burnham and Root. The Ruskinian Gothic–style house, completed in 1876 for the president of the stockyards, impressed a young Louis Sullivan, who wrote that it "seemed far better than the average run of such structures inasmuch as it exhibited a certain allure of style indicating personality." It was demolished in 1936. (Courtesy of the Art Institute of Chicago, Ryerson and Burnham Archives, Historic Architecture and Landscape Image Collection.)

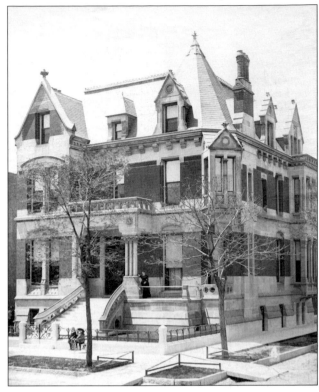

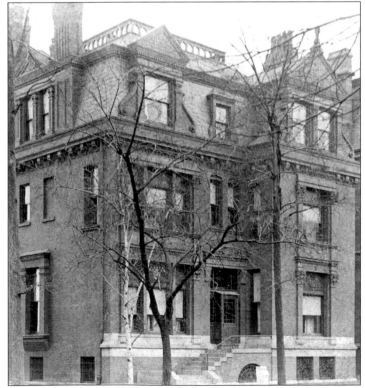

Prominent Chicago attorney Thomas Dent commissioned Burnham and Root to design his home of pressed brick and blue Bedford stone at 1823 South Prairie Avenue in 1881. He was known as "Judge" Dent throughout his career, although he never held that office. He sold the home to the Second Presbyterian Church in 1911 and then served two years as president of the Chicago Historical Society. The house was razed in 1945. (Courtesy of the Chicago History Museum.)

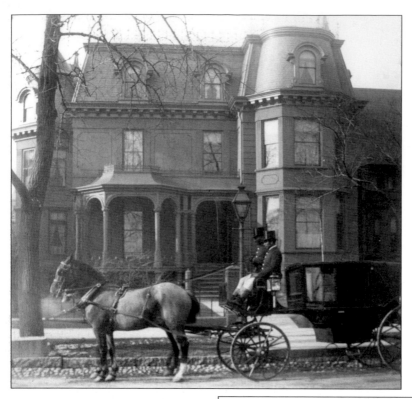

Turlington Harvey acquired the Staples house (see page 13) at 1702 South Prairie Avenue in 1880. Harvey was president of the Harvey Lumber Company and the founder of the town of Harvey. He commissioned C. A. Alexander to enlarge the house and create a new facade in the Second Empire style. In 1899, he sold the home to John Glessner, who razed it soon after (see page 47). (Courtesy of Bennet B. Harvey.)

The house at 1824 South Prairie Avenue (see page 13) was purchased by George B. Marsh in 1880 and soon after received a stone facade featuring Scotch granite pillars and an interior composed of beautiful and exotic woods. In 1897, the residence was acquired by insurance man Secor Cunningham, who scandalized society a decade earlier when he eloped with 16-year-old Althea Stone of 2035 South Prairie Avenue. (Courtesy of the Chicago History Museum.)

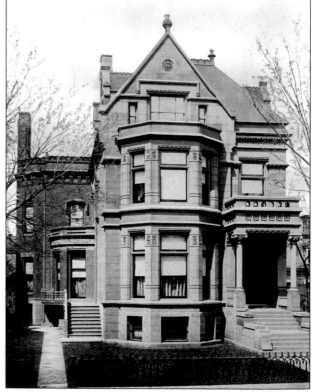

The residence for John W. Doane at 1827 South Prairie Avenue was among the largest on the street and featured such amenities as stained-glass windows by John LaFarge. It was completed in 1882 from plans by architect Theodore V. Wadskier. Doane was a grocery merchant, president of the Merchant Loan and Trust Company, and one of the founders of the Western Edison Light Company (now part of ComEd). (Courtesy of the Chicago History Museum.)

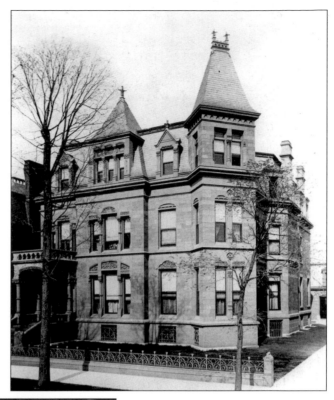

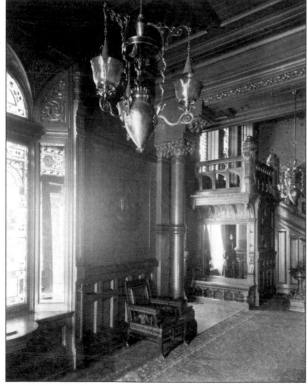

When the home was officially opened in November 1882 in celebration of the Doane's silver wedding anniversary, guests were treated to the first use of electric lights in a residence, powered by a generator in the coach house. By 1913, the house was converted into offices for the Radford Architectural Company, which remained until the structure was seriously damaged by fire in 1927. (Courtesy of the Art Institute of Chicago, Ryerson and Burnham Archives, Historic Architecture and Landscape Image Collection.)

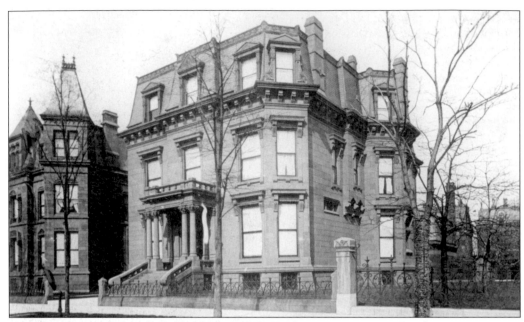

Lavall B. Dixon designed this home for O. R. Keith in 1882 at 1901 South Prairie Avenue, directly across the street from the homes of his two brothers. In 1886, Keith sold the residence to Norman B. Ream, who hired Burnham and Root to rebuild the top floor following a major fire in 1887. The house eventually became offices for the Radford Architectural Company and was razed in 1929.

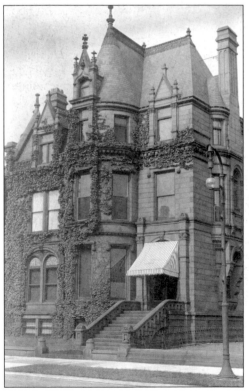

This stately châteauesque-style home at 1912 South Prairie Avenue was designed by Treat and Foltz for Byron P. Moulton in 1882. In 1898, it was acquired by future Illinois governor Frank O. Lowden. The widow of Timothy Blackstone, president of the Chicago and Alton Railroad, acquired the home in 1908 and remained until her death in 1928, at which time it was bequeathed to the Presbyterian Training School. The home was razed in 1939.

Joseph Sears, vice president of N. K. Fairbank and Company, commissioned Burnham and Root to design 1815 South Prairie Avenue in 1882. A unique feature of the property was a log cabin built as a playhouse for the Sears children, which survives today in Kenilworth. In 1902, the house was sold to Arthur Meeker, the European representative for Armour and Company, who significantly remodeled the house (see page 116).

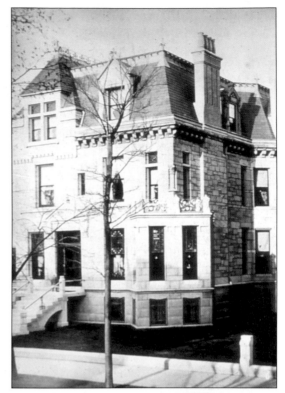

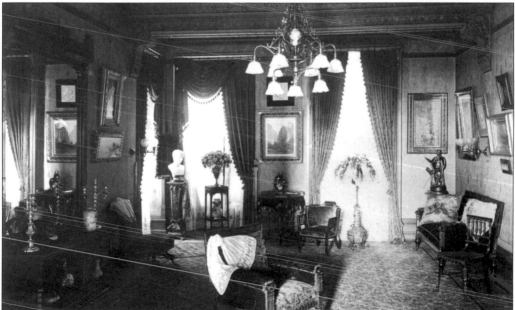

In 1883, Sears traveled to Europe, where he was inspired by the planned communities he visited. He returned to Chicago and purchased 200 acres on the north shore, creating the planned community of Kenilworth, to which he moved permanently in 1892. The house was leased to prominent attorney Levy Mayer for much of the next decade. The elegantly appointed parlor is shown here. (Courtesy of the Kenilworth Historical Society.)

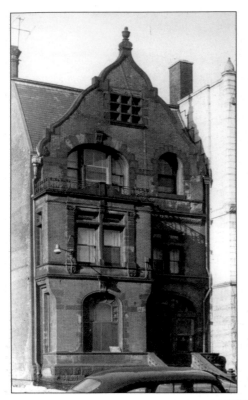

Burnham and Root designed this picturesque redbrick house in the Dutch vernacular–style in 1884 for George H. Wheeler, partner in a firm that operated grain elevators. The house was located at 1812 South Prairie Avenue and still possessed much of its unique character at the time this photograph was taken in the 1950s, by which point, it had been converted to furnished rooms. It was demolished in 1968. (Courtesy of the Chicago History Museum.)

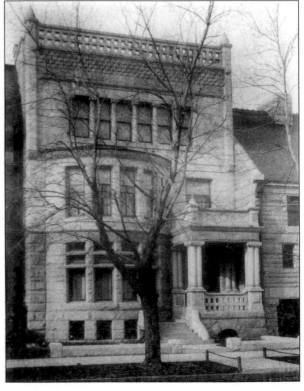

North of the Wheeler house stood the second home of O. R. Keith at 1808 South Prairie Avenue, designed by Cobb and Frost in 1886. The north wall of the Keith house formed the south wall of the adjacent Glessner house courtyard and was preserved when the Keith house was razed in 1968. From 1901 to 1913, the house was owned by Stanley Field, longtime president of the Field Museum.

Cobb and Frost designed the home at 1811 South Prairie Avenue in 1886 for hardware manufacturer Joseph Coleman. His wife died in 1888, and the home was acquired by coal merchant Miner T. Ames, who died in 1890. It was then leased for several years to David Mayer, partner in the retail firm of Schlesinger and Mayer. Today it houses offices for the U.S. Soccer Federation along with the adjacent Kimball house.

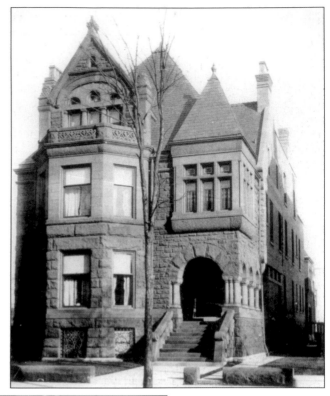

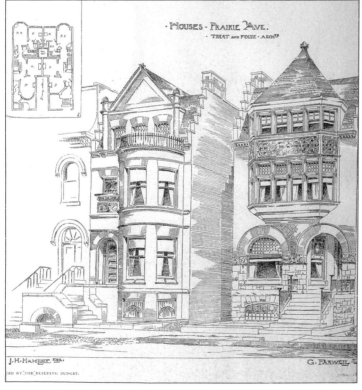

These two attached houses at 1621 and 1623 South Prairie Avenue were designed in 1886 by Treat and Foltz for John H. Hamline, an attorney, and Granger Farwell, a broker and president of the Chicago Stock Exchange. An interesting feature of the design was the shared driveway in between, which passed beneath the library and kitchen sections of the houses. Both buildings were demolished by 1941.

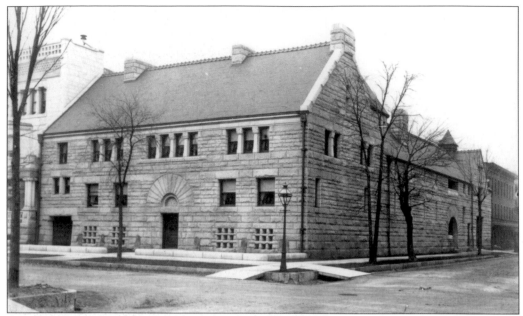

John and Frances Glessner commissioned architect Henry Hobson Richardson of Boston to design their home at 1800 South Prairie Avenue in 1885. The house was a radical departure from conventional residential design, pushing the walls out to the lot lines and focusing the main rooms onto a light-filled interior courtyard. Completed in 1887, it has come to be regarded as one of the most important residences designed in the United States.

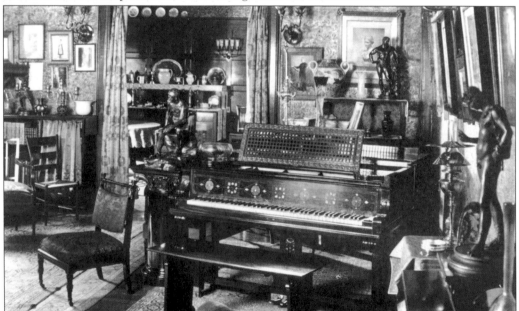

The interior of the Glessner home contained an important collection of English and American arts and crafts furnishings, including carpets and textiles by William Morris, tiles by William De Morgan, and furniture by Isaac Scott, Charles Coolidge, and Francis Bacon of A. H. Davenport and Company. This view shows the parlor in 1923. The restored residence is now a house museum and contains many of these original furnishings.

After leasing his home to controversial newspaper editor Wilbur Storey and spending several years in Europe, Fernando Jones returned to his Italianate-style residence at 1834 South Prairie Avenue (see page 15). In 1886, he enlarged the house and remodeled it in the popular Second Empire style. Jones died in 1911, and soon after, the house was sold to a furniture manufacturer. It was razed in 1942. (Courtesy of the Chicago History Museum.)

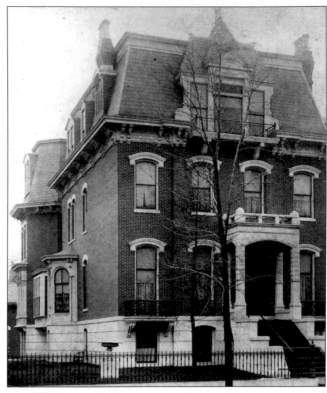

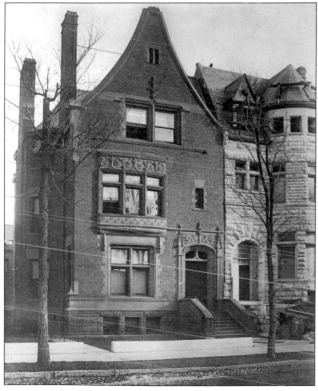

One of most unique designs to come from the office of Burnham and Root was this 1888 house at 2009 South Prairie Avenue, designed for boot and shoe manufacturer Max A. Meyer. The rock-faced brick facade featured finely detailed French Gothic motifs and an unusual concave pitched gable. Meyer died just as the house was being completed, but his family remained until 1908. It was demolished in 1955.

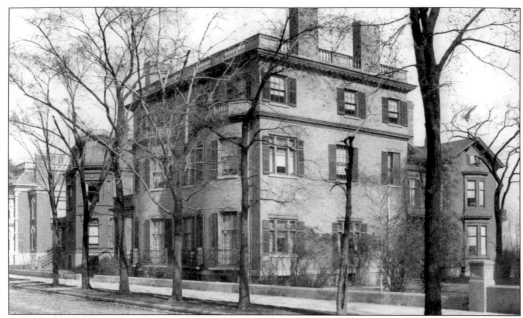

In 1889, Wirt Dexter commissioned Boston architect Arthur Little to design an addition to his home at 1721 South Prairie Avenue (see page 14), which came up almost to the front sidewalk, angering neighbor George M. Pullman. Dexter died in 1890, and Pullman acquired the house in 1897 but died soon after, leaving the task of moving the house back on its lot to the next owner. It was razed in 1927.

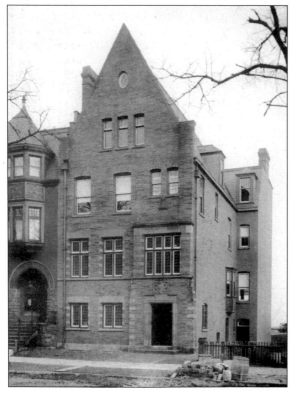

Francis M. Whitehouse designed this distinctive house for Hugh J. McBirney Jr. in 1889 at 1625 South Prairie Avenue. McBirney had grown up at 1736 South Prairie Avenue and was an officer of McBirney and Johnston White Lead Company. In later years, the firm merged with others to form the National Lead Company, which adopted the Dutch Boy logo for its line of paint products. The house was razed in 1937.

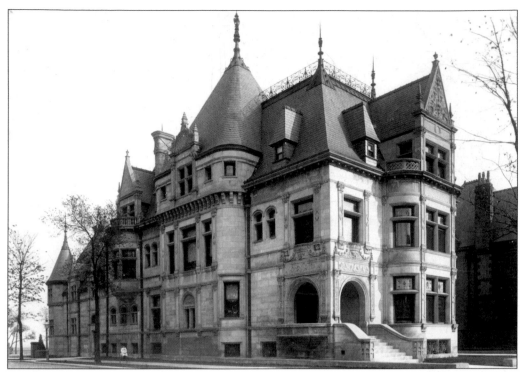

The last mansion-sized residence on the street was begun in 1890 at 1801 South Prairie Avenue for William W. Kimball, founder of the Kimball Piano and Organ Company. Designed by Solon S. Beman and completed in 1892, the massive structure housed the Kimball's collection of old master paintings, including works by Rembrandt, Thomas Gainsborough, and Sir Joshua Reynolds, which were bequeathed to the Art Institute of Chicago in 1921. (Courtesy of the Art Institute of Chicago, Ryerson and Burnham Archives, Historic Architecture and Landscape Image Collection.)

The Kimball house is loosely based on the Chateau de Josselin in Brittany and features exquisite stonework and an elaborate roofline with copper cresting. In 1925, it was converted into the Architect's Club of Chicago, which closed during the Depression and sold the house in 1943 for $8,000. It was later occupied by R. R. Donnelley and Sons and now serves as offices for the U.S. Soccer Federation.

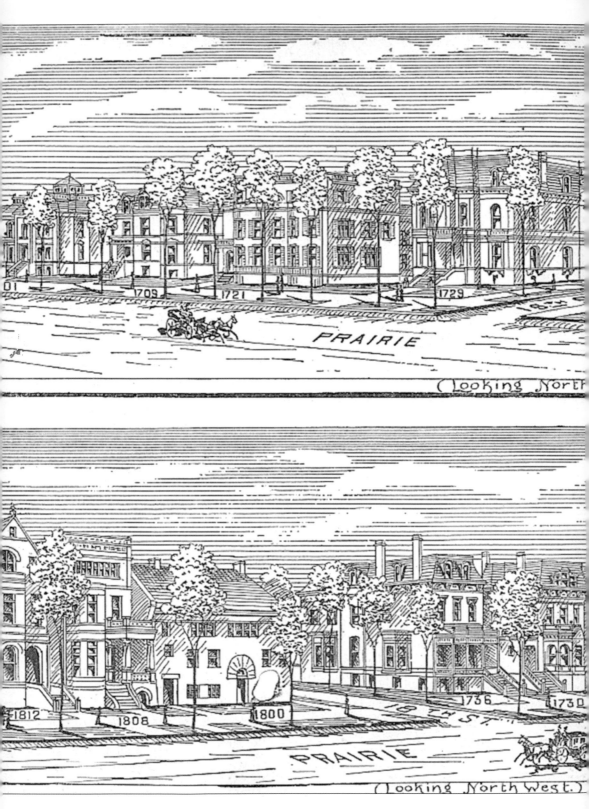

PRAIRIE

(looking North

1709 1721 1729

1812 1808 1800 PRAIRIE

18 TH ST. 1736 1730

(looking North West.)

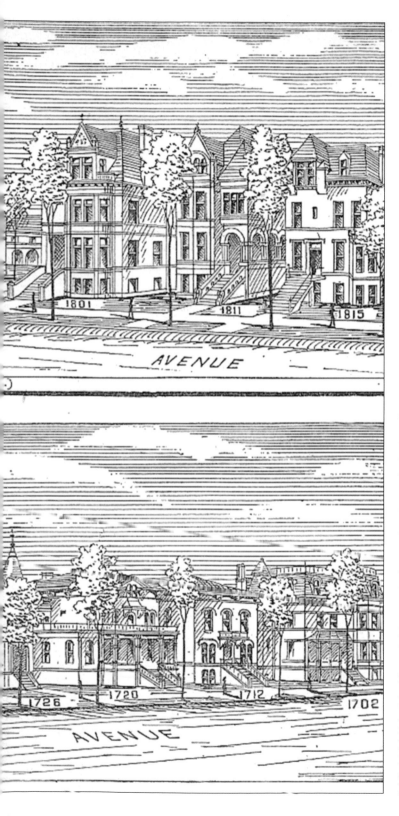

In 1898, Rand McNally and Company published *Bird's-Eye Views and Guide to Chicago,* which featured four detailed views of Prairie Avenue. Seen in the top view from left to right are 1701 South Prairie Avenue, home of William G. Hibbard; 1709 South Prairie Avenue, home of Jesse Spalding; 1721 South Prairie Avenue, vacant (formerly the home of Josephine Dexter); 1729 South Prairie Avenue, home of Harriet Pullman; 1801 South Prairie Avenue, home of William W. Kimball; 1811 South Prairie Avenue, home of David Mayer; and 1815 South Prairie Avenue, home of Levy Mayer. The bottom view, from left to right, shows 1812 South Prairie Avenue, home of George H. Wheeler; 1808 South Prairie Avenue, home of O. R. Keith; 1800 South Prairie Avenue, home of John J. Glessner; 1736 South Prairie Avenue, home of Hugh J. McBirney; 1730 South Prairie Avenue, home of Joseph E. Otis; 1726 South Prairie Avenue, home of James R. Walker; 1720 South Prairie Avenue, home of Ella Walker; 1712 South Prairie Avenue, home of Albert Sturges; and 1702 South Prairie Avenue, home of Turlington W. Harvey. (Courtesy of the Edward C. Hirschland collection.)

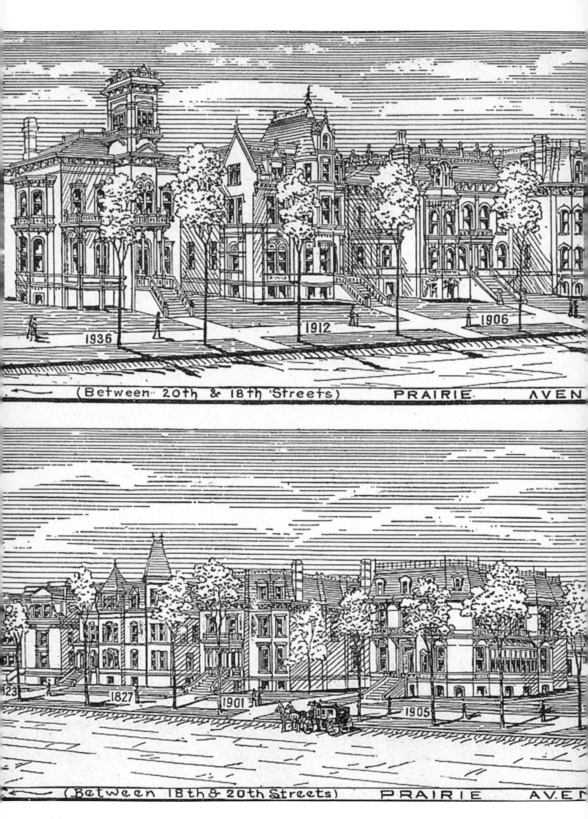

1936 1912 1906

(Between 20th & 18th Streets) PRAIRIE AVEN

23 1827 1901 1905

(Between 18th & 20th Streets) PRAIRIE AVE

44

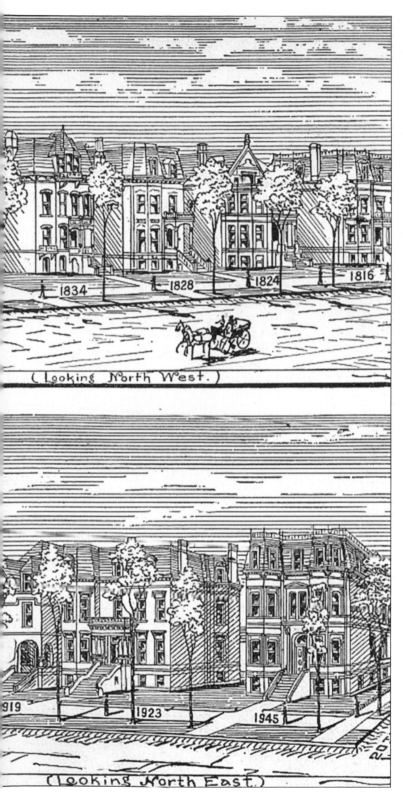

(Looking North West.)

(Looking North East.)

Here are two additional views from the 1898 *Bird's-Eye Views and Guide to Chicago.* From left to right, the top view shows 1936 South Prairie Avenue, home of Samuel W. Allerton; 1912 South Prairie Avenue, home of Frank O. Lowden; 1906 South Prairie Avenue, home of Susan Keith; 1900 South Prairie Avenue, home of Elbridge Keith; 1834 South Prairie Avenue, home of Fernando Jones; 1828 South Prairie Avenue, home of Daniel Shipman; 1824 South Prairie Avenue, home of Secor Cunningham; and 1816 South Prairie Avenue, home of Charles M. Henderson. From left to right, the bottom view shows 1823 South Prairie Avenue, home of Thomas Dent; 1827 South Prairie Avenue, home of John W. Doane; 1901 South Prairie Avenue, home of Norman B. Ream; 1905 South Prairie Avenue, home of Marshall Field; 1919 South Prairie Avenue, home of Walter W. Keith (renting from Marshall Field Jr., who was in England); 1923 South Prairie Avenue, home of Sarah Kellogg; and 1945 South Prairie Avenue, home of Isabelle Corwith. (Courtesy of the Edward C. Hirschland collection.)

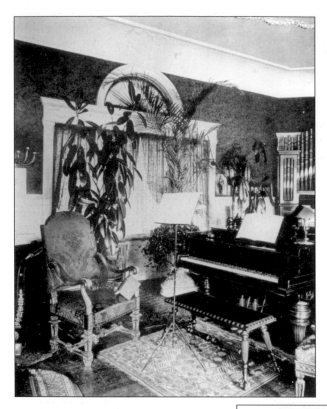

This is the music room addition to 2120 South Prairie Avenue, executed in the Federal style for Frank S. Gorton, treasurer of the Western Edison Electric Company. The house was designed by Burnham and Root in 1877 for commission merchant Ozro Wright Clapp. From 1908 to 1927, it housed the shop of Anna Perham, dressmaker for the Prairie Avenue set. The house was demolished in 1950.

The home of attorney J. Foster Rhodes at 1619 South Prairie Avenue, designed in 1891 by the firm of Beers, Clay and Dutton, replaced an earlier house on the site. The Rhodes house featured fine Greek Revival details, including the elegantly proportioned Doric-columned entrance portico and the roof cresting with anthemion. The house outlived all of its immediate neighbors and was razed in 1953.

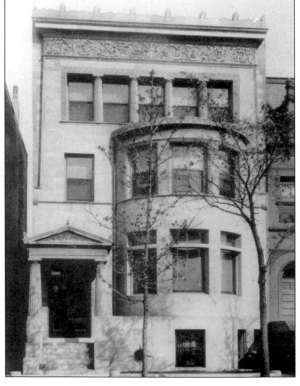

Beers, Clay and Dutton also designed this elegant classical revival row house for William H. Reid in 1894 at 2013 South Prairie Avenue. The third-floor Palladian window marks the location of the ballroom. The home has been remarkably well preserved and has been maintained as a single-family home throughout its history. Mary Neff, an attorney, rescued it from certain demolition in 1967 and lived here until her death in 2001.

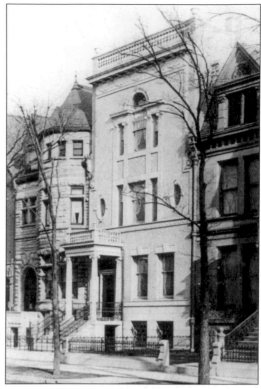

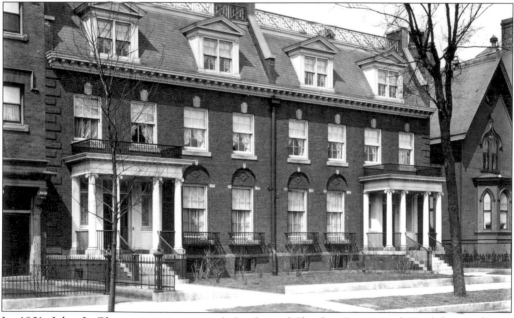

In 1901, John J. Glessner commissioned the firm of Shepley, Rutan and Coolidge to design these two redbrick Georgian-style town houses for his children. Completed in 1902, Glessner's son George and his wife, Alice, moved into the house at 1706 South Prairie Avenue (left), and daughter Fanny and her husband, Blewett Lee, moved into the house at 1700 South Prairie Avenue (right). Both houses were razed in 1954.

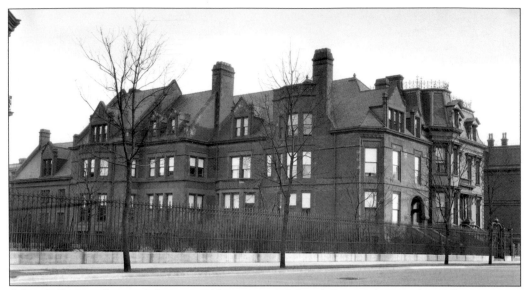

Solon S. Beman designed the original house at 1919 South Prairie Avenue for William Murray in 1883. In 1902, Marshall Field Jr. commissioned Daniel H. Burnham and Company to enlarge the residence. Within a few years of his death in 1905, the house was converted to a hospital and later a nursing home. After sitting empty for many years, it was restored and converted to six luxury condominium units in 2007. (Courtesy of the Chicago History Museum.)

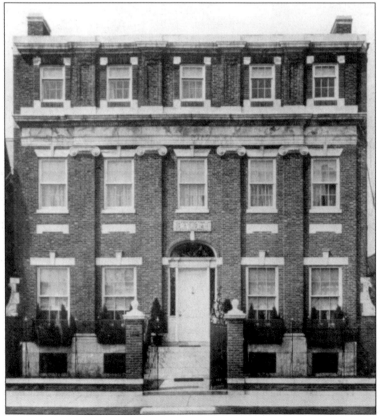

In 1904, meatpacker Edward F. Robbins razed the Hamill home at 2126 South Prairie Avenue (see page 18), retaining only the kitchen and servant wing at the rear. Mann, MacNeill and Lindeberg designed the new residence in the Federal style, featuring white marble trim. It was the last new residence built on Prairie Avenue for nearly 100 years. By 1915, it was converted into offices for World Book. It was razed in 2002.

Three

THE SURROUNDING
STREETS

Prairie Avenue was the center of the south side residence district, and the name came to identify the neighborhood as a whole. Calumet Avenue was located one block to the east, and in terms of both the residents and the architecture, it ranked equally with Prairie Avenue. The street was shorter, beginning about halfway into the 1800 block, due to the angle of the adjacent lakeshore. The considerable depth of the lots on the east side of the 2100 block resulted in a unique appearance, as all the houses were required to be set back 50 feet from the front lot line.

Indiana Avenue, located one block west of Prairie Avenue was distinctly different in character. Although there were some large houses, particularly north of Eighteenth Street, the street was impacted by the State Street trolley line, which turned east at Eighteenth Street and then turned at Indiana Avenue to continue south. As a result, most of the residences along this section were either row houses or more modest free-standing houses. A Presbyterian church and a Jewish synagogue dominated the intersection at Twenty-first Street.

Michigan Avenue, two blocks west of Prairie Avenue, was considered the finest roadway in the city, having been paved in the 1880s with white macadam that provided an incomparable drive. A number of substantial homes lined the street interspersed with several churches and elegant clubhouses.

Few houses were built on the east–west streets, and these tended to be attached houses built on 25-foot lots. Shops, private schools, a photography studio, and other businesses were located along Twenty-second Street (now Cermak Road), which marked the southern boundary of the neighborhood.

Prairie Avenue distinctly changed character at Twenty-second Street, as the lots became smaller to accommodate Cottage Grove Avenue crossing at an angle, and row houses and flats were common. However, at Twenty-sixth Street, the character of the street returned, and spacious lots accommodated prominent homes in the section that became known as lower Prairie Avenue. Similar in character to upper Prairie Avenue, this section continued south to Thirty-first Street, where smaller lots once again returned.

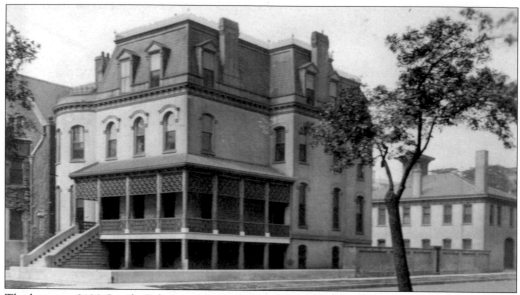

The home at 2100 South Calumet Avenue was built in the late 1860s for William Aldrich, who served three terms in the U.S. House of Representatives from 1877 to 1883. After his death in 1885, the house was sold to David B. Fisk, owner of the largest wholesale millinery west of the Hudson River. Two subsequent generations of his family occupied the house, which was demolished in 1938.

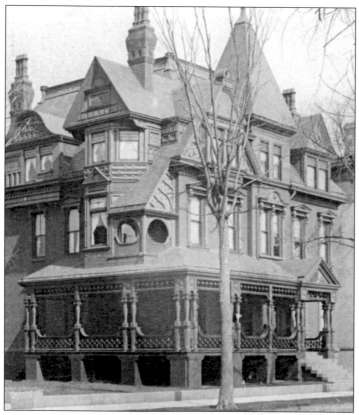

Levi Z. Leiter, retail partner of Marshall Field and major owner of downtown real estate, commissioned neighbor W. W. Boyington to build his home at 2114 South Calumet Avenue in 1870. In 1883, the house was acquired by John B. Drake, proprietor of the famed Grand Pacific Hotel. Drake engaged Cobb and Frost to remodel the house, which is seen here in the 1890s. It was demolished in 1935.

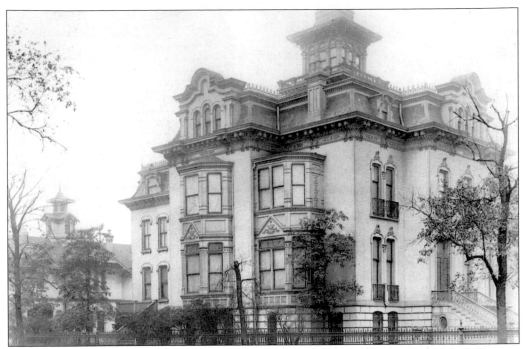

This home at 2032 South Calumet Avenue was completed in 1872 for Frederick Lehmann, partner in the brewing firm of Seipp and Lehmann. He died after being thrown from his carriage just weeks after the house was finished. In 1883, the property was acquired by Otto Young, owner of a huge wholesale jewelry business. The family sold the property in 1920, and it was razed soon after. (Courtesy of Linda Williamson.)

The home of Philander C. Hanford at 2008 South Calumet Avenue was designed in 1883 by the firm of Jaffray and Scott. Faced in Connecticut brownstone, the house cost $40,000 to build and contained Hanford's valuable art collection, including works by Titian and Rembrandt. The Hanford Oil Company was absorbed by Standard Oil in the late 1880s; he committed suicide in July 1894. The house was demolished in 1953.

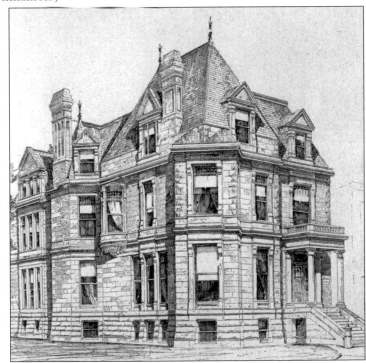

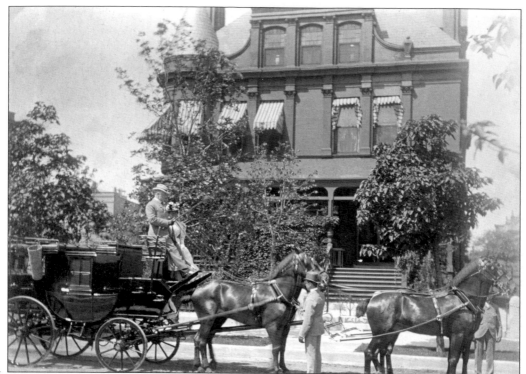

Burnham and Root designed this home at 1910 South Calumet Avenue for Arthur Caton (seated) in 1881. His parents and two sisters lived in homes immediately to the north, creating a Caton family "colony" along this stretch of Calumet Avenue. Caton was devoted to his horses and coaching. His carriage and coachmen John Mooney and Michael Dunn, seen here tending the horses, were frequently employed to carry visiting dignitaries while in Chicago. (Courtesy of the Newberry Library, Catherine Eddy Beveridge Papers.)

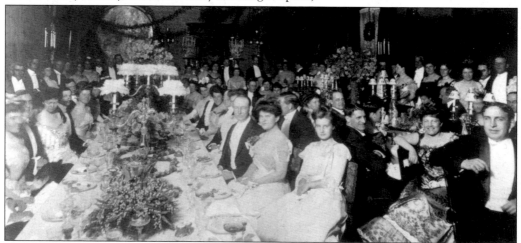

In 1897, Caton's wife, Delia, commissioned a dining room addition to the house that could comfortably seat 75 persons. The room featured dark oak paneling and old tapestries, and the tables were set with museum-quality porcelain or her famous solid gold plates. The dining room is seen here in 1901 for the debut party of Delia's niece Catherine Eddy of 1601 South Michigan Avenue. (Courtesy of the Newberry Library, Catherine Eddy Beveridge Papers.)

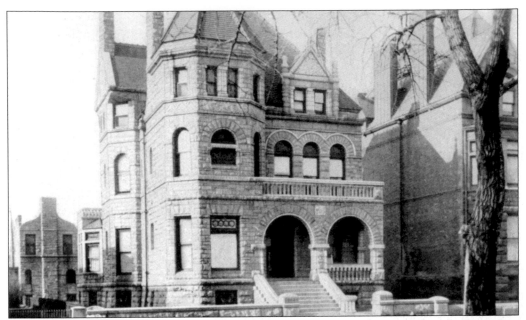

The residence at 2128 South Calumet Avenue was begun in 1886 but not completed until late 1888. It was built for John A. Davidson, president of Davidson and Sons, dealers and importers of marble. The house featured 14 rooms with a ballroom on the third level. All of the public spaces made extensive use of marble, onyx, and mosaics for floors, walls, fireplaces, and stairways. The house was demolished in 1949.

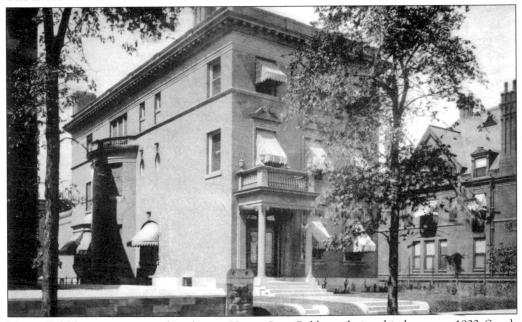

Henry Dibblee commissioned architect Henry Ives Cobb to design his home at 1922 South Calumet Avenue in 1891. Dibblee was a prominent dealer in ornamental ironwork, mantels, and imported tiles before organizing the real estate firm of Dibblee and Manierre in 1886. Dibblee's wife, Laura Field, was the sister of Marshall Field, who lived almost directly to the west on Prairie Avenue. The home was razed in 1933. (Courtesy of the Chicago History Museum.)

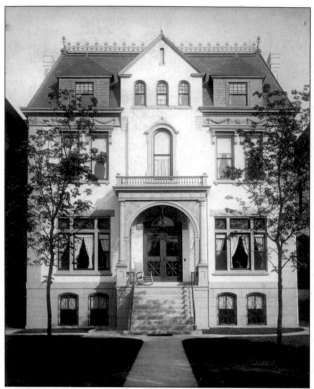

In 1887, George Moulton purchased the former home of Gen. John A. Logan at 2119 South Calumet Avenue (see page 15) and undertook a major remodeling. Moulton was an architect and builder of grain elevators and served as contractor for the Fisher and New York Life buildings. The residence was converted into a halfway house for women escaping the Levee vice district after it was sold in 1912.

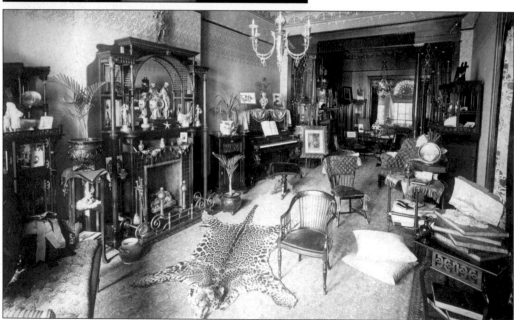

The lavish drawing room of the Moulton residence featured detailed wall and ceiling stenciling and exotic touches, such as the leopard skin rug. Alterations, which totaled nearly $15,000, included the building of a conservatory, the conversion of the attic into a billiard room, the rebuilding of the reception hall with oak paneling and a richly carved stairway, and the addition of hot water heat. The house was demolished in 1928.

Following the death of John Dean Caton in 1895, his home at 1900 South Calumet Avenue was razed and replaced with this Georgian-style home, designed in 1899 by Howard Van Doren Shaw for Charles A. Starkweather. In 1901, Shaw designed a new house for Starkweather in Hyde Park, and the Calumet Avenue residence was sold to Lawrence Heyworth, who founded the South Shore Country Club in 1906. The house was razed in 1939.

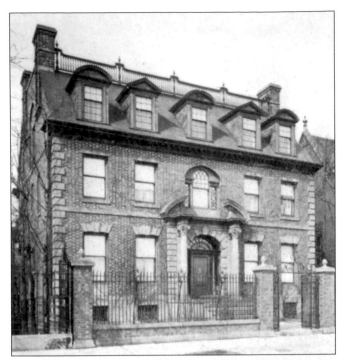

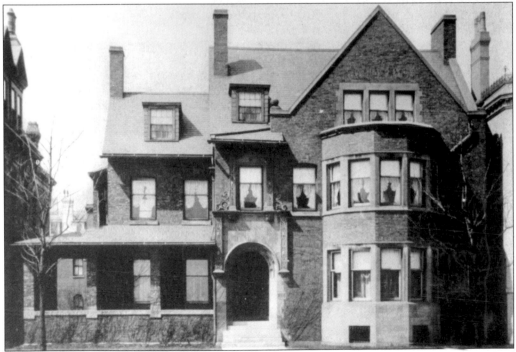

John B. Drake Jr., who had grown up at 2114 South Calumet Avenue, acquired and demolished the neighboring home of Alpheus C. Badger at 2106 South Calumet Avenue in 1901 and commissioned Shaw to design this house, executed in the Tudor style. Drake and his brother Tracy operated the Drake Hotel Company that built and managed both the Blackstone and Drake hotels. The home was demolished in 1936.

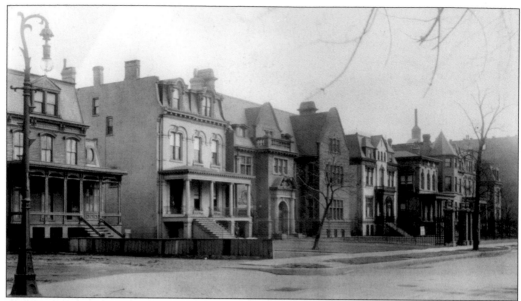

The stately brick home at 2109 South Calumet Avenue built in 1905 for Finley Barrell, seen at center, was slated for demolition in 1912 when R. R. Donnelley and Sons acquired the entire block on which to build their new Lakeside Press building. The house was sold for $3,000 to a buyer who salvaged the mantelpieces, carved mahogany dining room, and exterior stonework to recreate the house in Patterson, New Jersey. (Courtesy of the Special Collections Research Center, University of Chicago Library.)

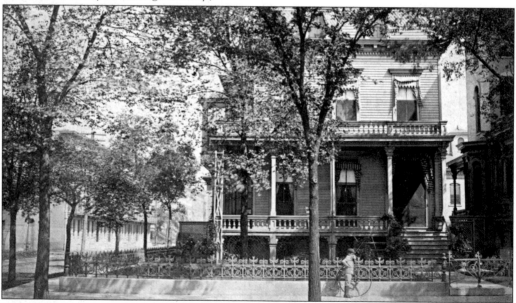

The frame home at 1601 South Michigan Avenue served as the residence of the George M. Pullman family for a period of time before and after the Chicago Fire. However, it was long occupied by Franklin Fayette Spencer, vice president of the wholesale hardware firm of Hibbard, Spencer, Bartlett and Company. His daughter Abby Spencer Eddy abandoned the family home in 1906 as business began to encroach on the street and it was razed soon after. (Courtesy of the Newberry Library, Catherine Eddy Beveridge Papers.)

The large residence at 1912 South Michigan Avenue was presented to Maria Root by her father at the time of her marriage to Hugh Birch in 1876. Birch was a successful corporate attorney and served for a time as assistant state's attorney. He began buying large parcels of land in Florida, including most of present-day Fort Lauderdale, and he later donated huge tracts to the state for use as nature preserves. (Courtesy of the Newberry Library, Catherine Eddy Beveridge Papers.)

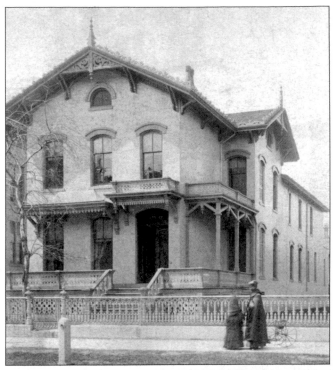

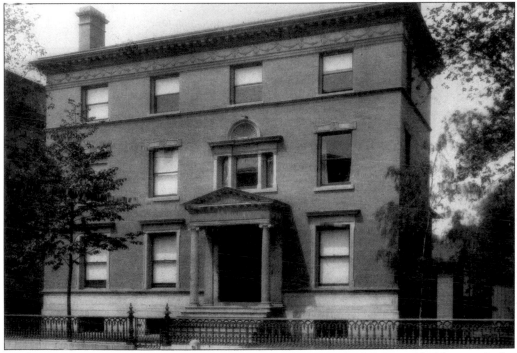

Birch's success as an attorney and as general counsel for Standard Oil provided him with the resources to build a huge addition on the front of his house. In 1890, he commissioned architect Henry Ives Cobb to design this three-story brick structure, whose understated elegance reflected Birch's own views toward ostentatious displays of wealth.

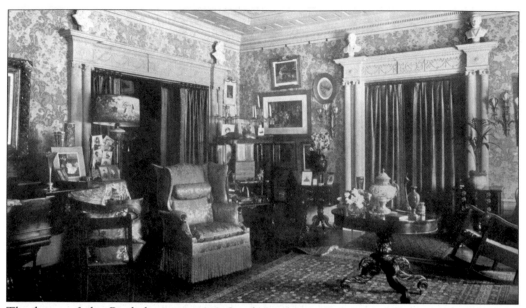

The heart of the Birch home at 1912 South Michigan Avenue was the music room. Both Maria Root Birch and her daughter Helen were accomplished pianists, the latter composing several sonatas. In 1919, Helen married artist Frederic Clay Bartlett, with whom she amassed an important collection of Postimpressionist paintings, including Georges Seurat's *La Grande Jatte*, which was given to the Art Institute of Chicago following her death in 1925.

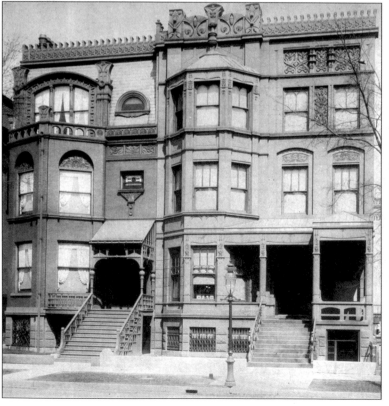

The Anna McCormick and Morris Selz houses at 1715–1717 South Michigan Avenue were the only two residences in the neighborhood designed by Louis H. Sullivan (1884 and 1883 respectively). When the Selz house was demolished in 1967, a cast-iron newel post from the exterior staircase was preserved and is included in the display of architectural fragments around the grand staircase of the Art Institute of Chicago.

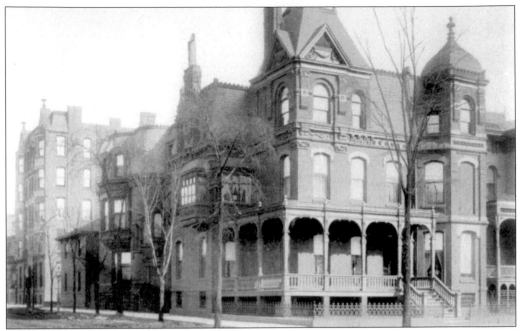

Nathaniel K. Fairbank constructed this home in the early 1880s at 1801 South Michigan Avenue. Fairbank arrived in Chicago in 1855 and made his fortune in the board of trade before founding N. K. Fairbank and Company in 1864. The firm used the by-products of the meatpacking industry to make lard, Cottolene, and soaps, including those marketed under the Gold Dust Twins logo.

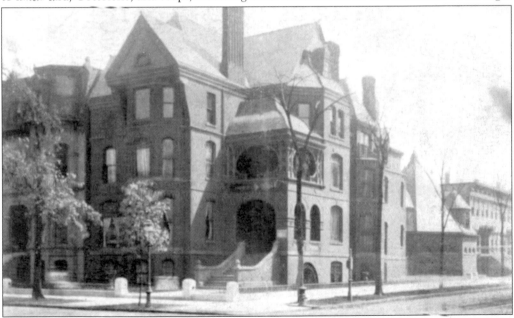

The home of Gen. Anson Steger at 1733 South Michigan Avenue was designed in 1883 by Solon S. Beman and featured a huge stable that could accommodate 10 horses. The house received considerable notoriety when it was announced that the Vanderbilts leased the residence in 1893 for the entire period of the World's Columbian Exposition. In the years following, it housed the Christofle Art Rooms.

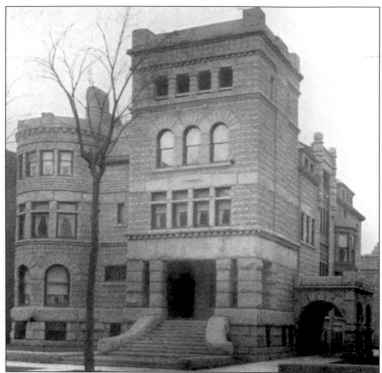

William Le Baron Jenney designed this residence for Ferdinand Peck at 1826 South Michigan Avenue in 1889. Peck was president of the Auditorium Association and sponsored and brought to completion the combination hotel, opera house, and office building. Following the dedication of the Auditorium building in 1889, Peck entertained Pres. Benjamin Harrison, who delivered the dedicatory address, in his newly completed home.

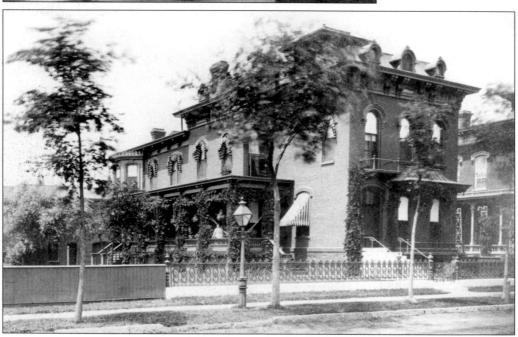

One of a small number of large, freestanding homes located on Indiana Avenue was the home of George P. Gore, constructed about 1879 at 1926 South Indiana Avenue. Gore was the owner of the George P. Gore and Company auction house. The house and large, landscaped lot were targeted in the early 1900s as light industry began to invade the area, and the house was demolished in 1905. (Courtesy of the Chicago History Museum.)

This Queen Anne–style house was designed in 1892 by the firm of Thomas and Rapp. Located at 217 East Twentieth Street (now Cullerton Street), the house was a major rebuilding of an earlier one that matched the three-story Italianate house visible at right. Used as a rental property, it was commissioned by John M. Clark, whose own home stood immediately to the east at 2000 South Prairie Avenue. (Courtesy of Thomas Yanul.)

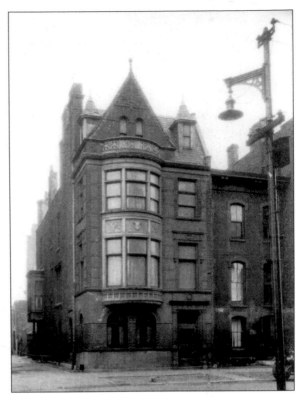

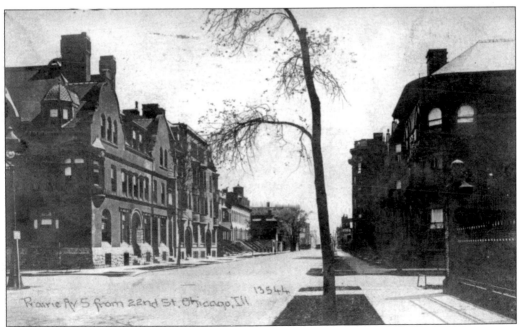

The character of Prairie Avenue quickly changed at Twenty-second Street, as seen in this view looking south in the early 1900s. Although the southwest corner was occupied by a substantial dwelling designed by Cobb and Frost for Dr. E. M. Hale, the rest of the block was taken up largely with row houses and flats, which could easily be accommodated on the small lots.

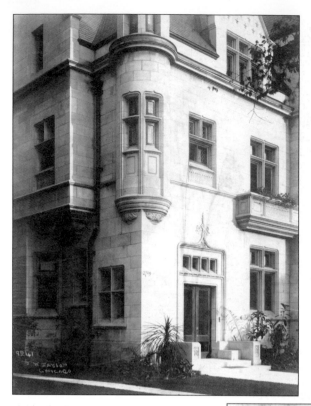

George O. Garnsey designed the original home at 2709 South Prairie Avenue for Charles L. Hutchinson in 1881. Seven years later, Hutchinson commissioned Francis M. Whitehouse to enlarge and redesign the house in the French Gothic style as seen here. Hutchinson was vice president of the Corn Exchange Bank started by his father and served as president of the Art Institute of Chicago from 1882 until his death in 1924. (Courtesy of the Art Institute of Chicago, Ryerson and Burnham Archives, Historic Architecture and Landscape Image Collection.)

The residence of Frank G. Logan at 2919 South Prairie Avenue was designed in the early 1880s by the firm of Wheelock and Clay, which is credited with being the first to utilize encaustic tiles for exterior decoration, as seen on this home. Logan was a prominent broker and member of the board of trade and amassed an important collection of fine art and rare books in the home. (Courtesy of the Art Institute of Chicago, Ryerson and Burnham Archives, Historic Architecture and Landscape Image Collection.)

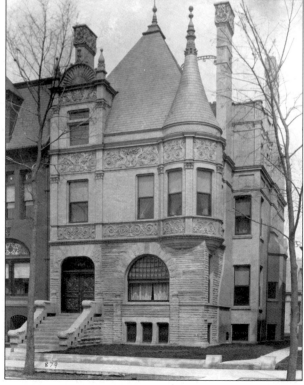

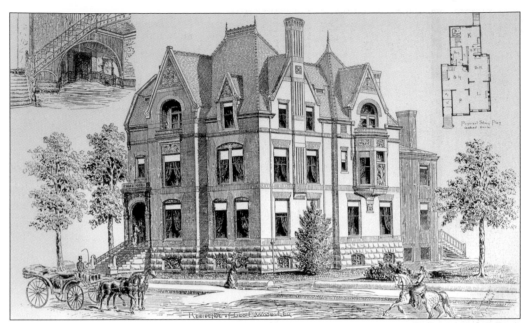

John C. Cochrane designed the house at 2801 South Prairie Avenue in 1885 for George Wood, owner of a large lumber company. In 1948, it was acquired by an African American couple, Charles and Alva Maxey-Boyd, who spent years overcoming prejudice and the wave of urban renewal to preserve their home. In 2003, both the exterior and interior of this last surviving home on lower Prairie Avenue were landmarked by the city.

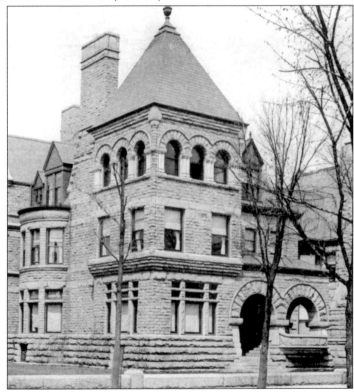

This Romanesque-style home at 2720 South Prairie Avenue was built for Adolphus Clay Bartlett in 1886, utilizing plans by Cobb and Frost. Bartlett was the junior partner in the wholesale hardware firm of Hibbard, Spencer, Bartlett and Company and a longtime trustee of the Art Institute of Chicago. Both of his daughters went on to found museums, and his artist son Frederic Clay became a major collector.

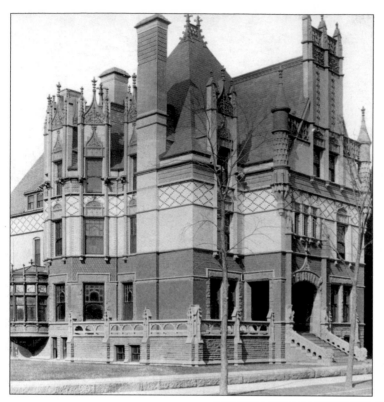

Edwin Pardridge was the owner of this elaborate French Gothic–inspired residence at 2808 South Prairie Avenue, designed in 1886 by the firm of Wheelock and Clay. The polychromatic exterior featured details in orange, blue, and purple. Pardridge made his fortune in the dry goods business and, at the time of his death in 1896, was called the most aggressive bear speculator in the history of the Chicago Board of Trade. (Courtesy of the Art Institute of Chicago, Ryerson and Burnham Archives, Historic Architecture and Landscape Image Collection.)

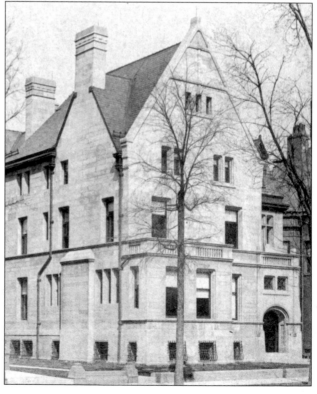

The house at 2700 South Prairie Avenue was designed in 1888 by Burling and Whitehouse for O. S. A. Sprague. Sprague and his brother Albert, who lived next door at 2710 South Prairie Avenue, were the founders of the mercantile house of Sprague, Warner and Company. He moved to California in the late 1890s on account of his health and sold the house to Henry Lytton, proprietor of the Hub clothing store.

This unusual granite-faced home at 2904 South Prairie Avenue was designed by Solon S. Beman in 1888 for Milton R. Wood. By the mid-1920s, the house had been acquired by Emma Ludwig, better known as Vic Shaw, a legendary madam in the early 1900s Levee district. She had frequent encounters with law officials, who charged her with running a "vice resort" out of the once elegant home.

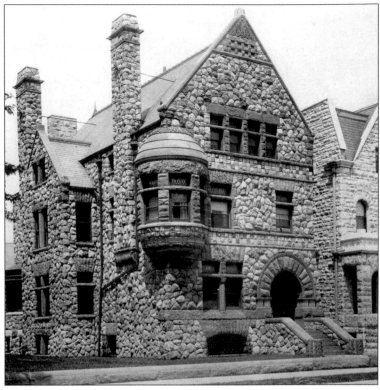

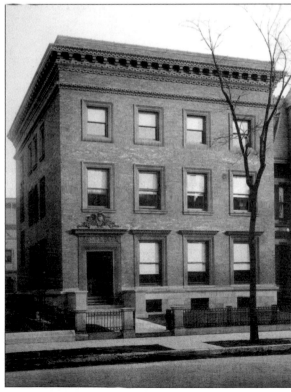

Noble Judah engaged the services of Shepley, Rutan and Coolidge to design this Renaissance Revival–style residence at 2701 South Prairie Avenue in 1896, replacing a frame home he had occupied on the site for many years. Judah was the senior partner in the law firm of Judah, Willard, Wolf and Reichmann, and was the brother-in-law of Charles L. Hutchinson, who lived two doors to the south.

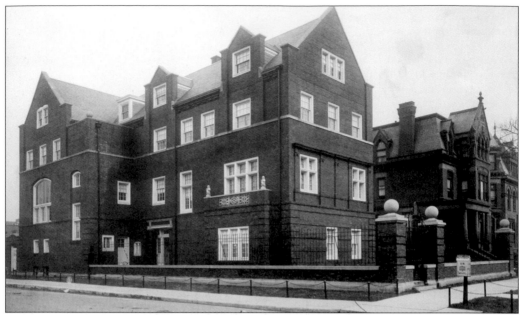

Noted artist Frederic Clay Bartlett hired the architectural firm of Frost and Granger to design this distinctive brick residence at 2901 South Prairie Avenue in 1901. Bartlett spent several years studying art in Europe and was one of the few Americans to be admitted to the Royal Academy in Munich. He designed murals for the Second and Fourth Presbyterian Churches, Chicago City Hall, the University Club, and the Bartlett Memorial Gymnasium.

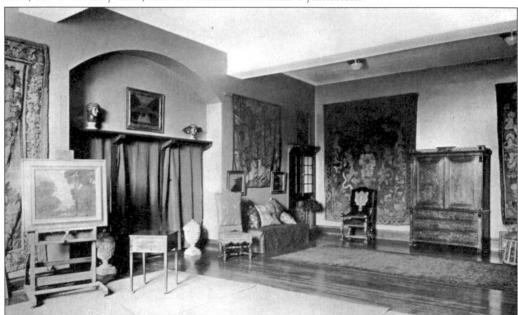

The interior of Bartlett's home, including his studio shown above, was among the most artistic and unique of any residence in the city and reflected his years spent abroad. One of his canvases, done in the Impressionist style, is visible at the far left. He later built a winter residence known as Bonnet House in Fort Lauderdale, Florida, which contains many of his works and is open to the public as a house museum.

Four

CHURCHES, SCHOOLS, AND MORE

Although the pride of the neighborhood was its fine homes, significant nonresidential structures spoke to the taste and refinement of the residents. Chief among these were the churches; more than a dozen were located in the immediate area. Christ Episcopal and Grace Episcopal were established in the neighborhood in the 1860s, but the majority moved here immediately after the Chicago Fire, when their downtown buildings were destroyed. Indiana and Michigan Avenues were the most popular locations for churches representing the Presbyterian, Episcopal, Methodist, Unitarian, Universalist, and Baptist faiths and at least three synagogues for Orthodox and Reformed congregations. By the early 1920s, most relocated to other parts of the city as their membership scattered. Today only Second Presbyterian and Trinity Episcopal churches remain in the neighborhood.

Schools represented another important classification of structures. Haven School, the prominent public school located west on Wabash Avenue, dated to 1862, but most others evolved as the population grew in the 1870s. The majority of children on the street attended private schools, of which the most prestigious were the Harvard School for Boys at Indiana Avenue and Twenty-first Street and the Dearborn Seminary at Calumet Avenue and Twenty-second Street. Numerous other schools operated in former residences, and the majority moved out of the area in the 1890s or simply closed as the local population aged.

Other buildings included two prominent clubs, the Calumet Club and the Standard Club, which were each housed in elegant structures built on Michigan Avenue in the 1880s. The fortresslike First Regiment Armory at Michigan Avenue and Sixteenth Street served as an unofficial gateway into the neighborhood from downtown. It was built on land leased by Marshall Field, who, along with his neighbors, saw the advantages of having the national guard nearby in the turbulent years of labor unrest following the Haymarket Riot of 1886.

Businesses, including the studio and gallery of society photographer Mathew Steffens and Bournique's Dancing Academy, thrived during the heyday of the neighborhood but closed or relocated in the second decade of the 20th century when the neighborhood experienced a dramatic transformation.

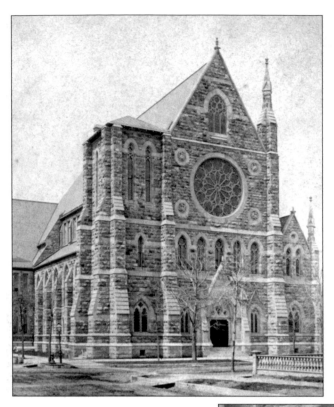

Second Presbyterian Church was organized in 1842. Following the Chicago Fire, it commissioned New York architect James Renwick to design a new building at 1936 South Michigan Avenue in the English Gothic style, which was completed in 1874. A bell tower, part of Renwick's original design, was added in the 1880s as a memorial to George Armour.

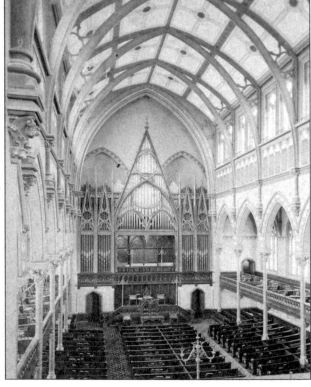

Renwick had also designed the previous building for Second Presbyterian, completed in 1851 at the northeast corner of Wabash Avenue and Washington Street. It was considered an important early work of Gothic Revival in the city of Chicago. The interior of the new building, shown here, exhibits Renwick's mastery of the Gothic style with its elaborate organ case and pulpit.

A devastating fire in March 1900 completely gutted the sanctuary and destroyed the roof. The large rose window by John LaFarge was lost as were several side windows by the Tiffany studios, although one, depicting an angel in a field of lilies, survived partially intact and remains today. The limestone walls were judged sound, and the rebuilding of the church was complete by late 1901. (Courtesy of Second Presbyterian Church.)

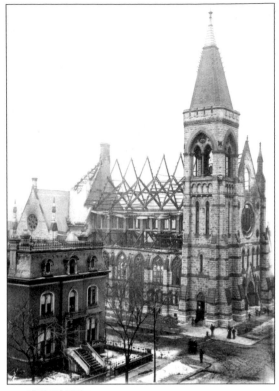

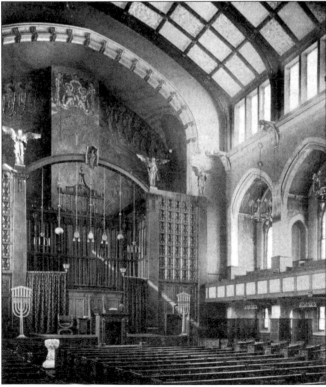

Architect and longtime church member Howard Van Doren Shaw designed the new sanctuary in the emerging arts and crafts style, and today it is widely considered one of the largest and most intact arts and crafts interiors in the country. Pre-Raphaelite murals by Frederic Clay Bartlett, nine Tiffany memorial windows, and two rare Edward Burne-Jones windows made in the William Morris Studio add further significance to the space.

69

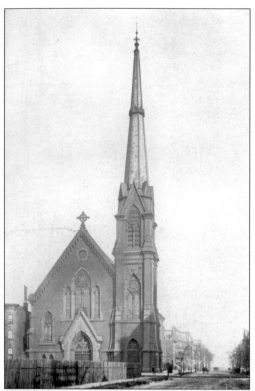

First Presbyterian Church was located at 2035 South Indiana Avenue. Organized at Fort Dearborn in 1833, it is today the oldest continually operating organization in the city of Chicago. John C. Cochrane, architect of the Illinois state capitol, designed the brick building that possessed the highest spire in the city. Dedicated in 1873, the last service was held here in 1912 after which the congregation moved south to Forty-first Street.

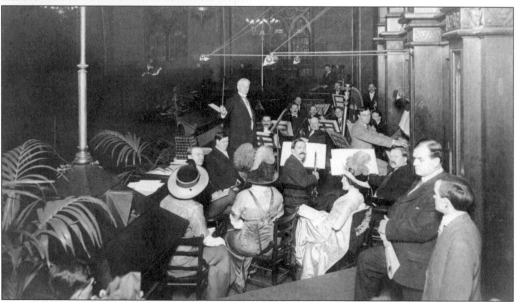

The sanctuary of the First Presbyterian Church featured black walnut trim, decorations by Frederic Clay Bartlett, and three Tiffany windows later moved to the Second Presbyterian Church. The music program, led by talented musician and composer Philo Adams Otis of 1709 South Prairie Avenue, was considered one of the finest of any church in the city, and the orchestra included several members of the Chicago Symphony. Marshall Field was a longtime trustee of the congregation.

The Sinai congregation was established in 1861 as the first reformed synagogue in the city of Chicago. Architects Burling and Adler designed this handsome building for the congregation, completed in 1876 at 2100 South Indiana Avenue. By 1912, the decision was made to relocate farther south, following the migration of its members, and the building was razed that year. Today the congregation is located at 15 West Delaware Place.

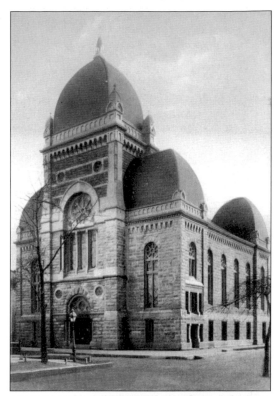

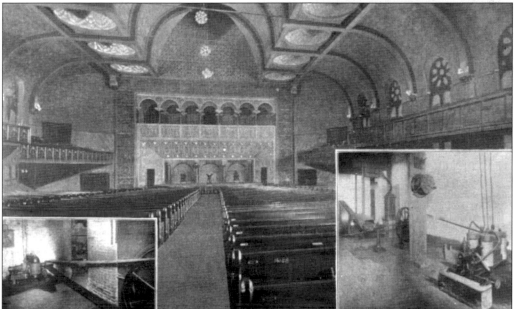

The interior of Sinai temple was significant in that it contained the earliest documented work by a young Louis H. Sullivan, who completed "fresco secco" decorations in the spacious auditorium. Adler and Sullivan returned to the building in 1884 to add the galleries seen here at either side and again in 1891 to construct a large addition to the rear and extensively remodel the interior. (Courtesy of Chicago Sinai Congregation.)

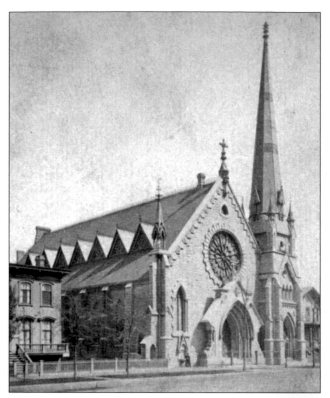

Grace Episcopal Church was organized in 1851 by members splitting from the Trinity congregation. In 1868, architect William Le Baron Jenney was commissioned to design its new building at 1439 South Wabash Avenue, which was completed the following year. In 1915, the church was destroyed by fire, and the congregation completed a new building at 1446 South Indiana Avenue adjacent to St. Luke's Hospital, which still stands but is no longer used by the congregation.

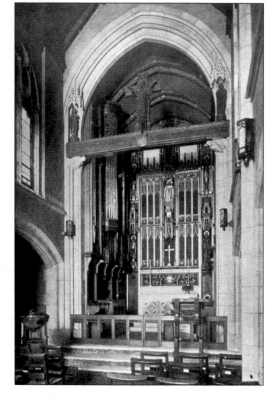

The Hibbard Memorial Chapel, designed by the firm of Cram Goodhue and Ferguson, was completed in 1906 immediately north of Grace church. Donated by Lydia Beekman Hibbard in memory of her husband, William, who had died in 1903, the space was described as the "most exquisite example of perpendicular Gothic architecture in America." It was destroyed in the 1915 fire.

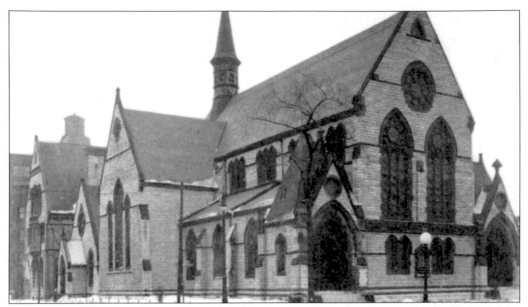

Trinity Episcopal Church, organized in 1842, completed this building at the southeast corner of Michigan Avenue and Twenty-sixth Street in 1874, with the parish house at far left added in 1894. In 1920, the main sanctuary was destroyed by fire, and the chapel was converted into the sanctuary and remodeled by Tallmadge and Watson in the 14th century Gothic style. The bronze lectern still used today was purchased at the World's Columbian Exposition. (Courtesy of the Archives and Historical Collections, Episcopal Diocese of Chicago.)

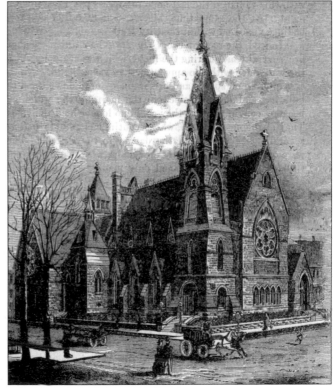

The Church of the Messiah, located at the southeast corner of Michigan Avenue and Twenty-third Street, began as the First Unitarian Society of Chicago in 1836. In 1873, its new building was completed under plans by architect John C. Cochrane. That building, seen here, was constructed of Joliet limestone and featured a 120-foot campanile and richly colored frescoing in the sanctuary.

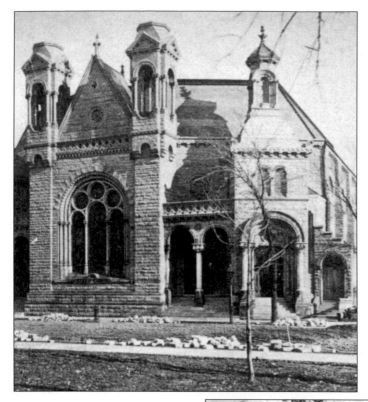

Plymouth Congregational Church completed this building at 2535 South Michigan Avenue in 1873. The structure cost $100,000 to build and sat 1,600 people. In 1892, prominent church member Philip D. Armour hired the pastor, Dr. Frank W. Gunsaulus, to serve as the first president of the newly created Armour Institute. The building was sold in 1910, and the congregation relocated to a new structure on East Fiftieth Street.

Christ Episcopal Church began in 1859, and started construction on this building at 2401 South Michigan Avenue in 1864. In 1873, Rev. Charles E. Cheney split from the Episcopal diocese over theological issues, and the congregation aligned with the newly organized Reformed Episcopal Church. The building was sold in 1920, but several original Tiffany windows have been reinstalled in the present building in Tinley Park.

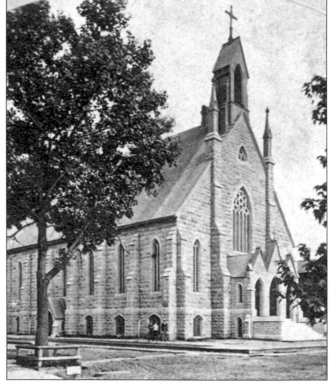

St. Paul's Universalist Church completed its previous building on the 1700 block of Michigan Avenue in 1873. In 1887, it commissioned Burling and Whitehouse to design a new building at 3005 South Prairie Avenue, shown here. The Romanesque-designed structure was built of Lake Superior sandstone and featured a beautiful chapel donated by Charles L. Hutchinson and Harlow Higinbotham. It was the only nonresidential structure built on lower Prairie Avenue. (Courtesy of the Chicago History Museum.)

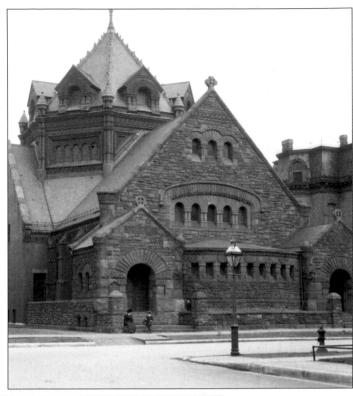

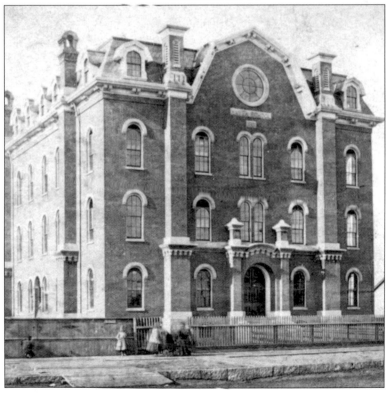

Architect G. P. Randall designed the Haven School at 1472 South Wabash Avenue. When the school opened in 1862, it accommodated 756 pupils and was the first public school to contain a gymnasium. The total cost of construction, including furniture, was $22,000. Many early Prairie Avenue families sent their children to the school, which was replaced with a larger structure in 1885.

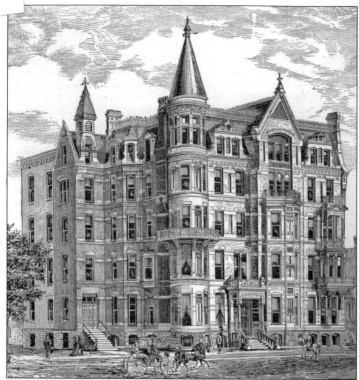

Allen's Academy for Boys opened in 1874 at Michigan Avenue and Twenty-second Street. The principal, Ira W. Allen, had previously served as head of Lake Forest Academy. In 1883, Allen engaged the services of architect Charles Chapman to design the larger five-story building seen here, which was located on the south side of Twenty-second Street between Prairie and Calumet Avenues. The school closed upon Allen's retirement in 1892.

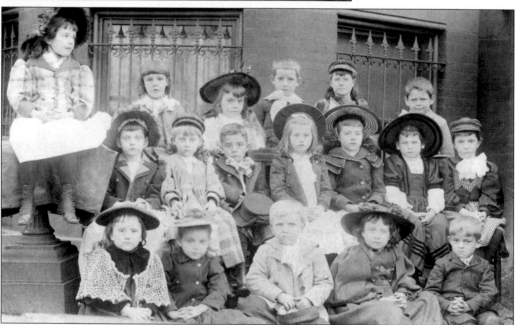

The Holman-Dickerman French and English Day School operated out of the residence at 2115 South Indiana Avenue from 1879 until 1901. For many years, it was a girls' school, but it became coeducational by the 1890s when this class picture was taken. At least one Prairie Avenue child is shown–Leslie Grant–who was being raised by her grandparents Mr. and Mrs. Fernando Jones in their home at 1834 South Prairie Avenue.

In 1880, the Illinois Central Railroad purchased property at 1605 South Prairie Avenue for the construction of this Italianate-style depot, seen here in 1896. Although it was the only nonresidential structure on the street, the depot was a great convenience to residents, as it was another 13 years before the railroad's main central station was completed a half-mile to the north. (Courtesy of the Illinois Central Railroad Historical Society.)

A second depot for the Illinois Central Railroad was constructed at the south end of the neighborhood, a block east of Calumet Avenue just south of Twenty-second Street. Prairie Avenue residents filed petitions against the railroad regarding the environmental effects of the increasingly heavy railroad traffic as well as fighting to regain ownership of the waterfront. That fight proved successful as a result of an 1892 U.S. Supreme Court decision.

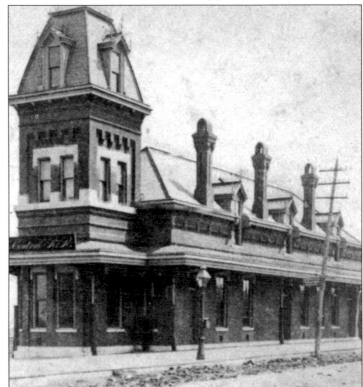

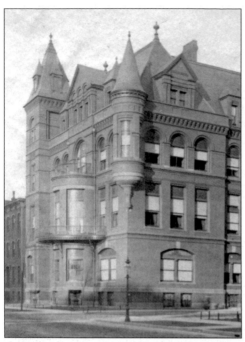

The Calumet Club, one of Chicago's most exclusive, was organized in 1878 in a building at Michigan Avenue and Eighteenth Street. In May 1882, it opened its Burnham and Root–designed clubhouse, seen here, at the northeast corner of Michigan Avenue and Twentieth Street. The building was destroyed by fire in January 1893, taking with it valuable historic relics of early Chicago and paintings by Gilbert Stuart and G. P. A. Healy.

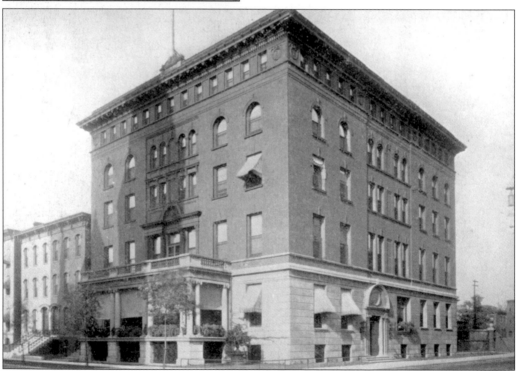

The new Calumet Club building was opened in November 1894 on the site of the previous structure. Designed by architect Charles S. Frost, the interior was richly ornamented and featured extensive use of rare marbles. Spaces included a huge reading room, a billiard room, a conservatory, a dining room, and a card room on the first two levels, with private sleeping rooms above. The club closed in November 1914.

The Standard Club was one of the largest Jewish social organizations in the country. Organized in 1869, it completed a new clubhouse at the southwest corner of Michigan Avenue and Twenty-fourth Street in 1889. The building was designed by Adler and Sullivan and cost $115,000 in addition to $40,000 for furniture. In the mid-1920s, the club relocated to a new Louis Kahn–designed building in the Loop.

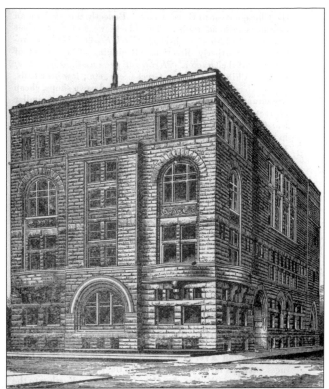

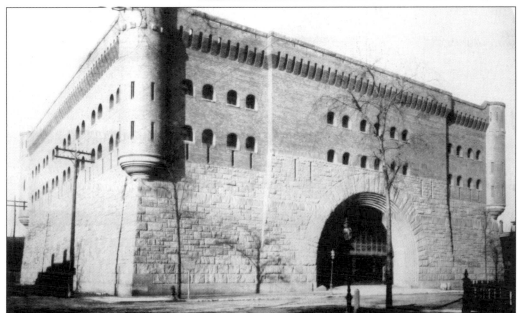

One of the most unusual structures in the area was the imposing First Regiment Armory, completed in 1891 at the northwest corner of Michigan Avenue and Sixteenth Street. The massive structure with four-foot-thick brownstone walls at the base was said to resemble a "feudal castle of medieval times." It was designed by Burnham and Root, which rebuilt it in 1894 following a devastating fire.

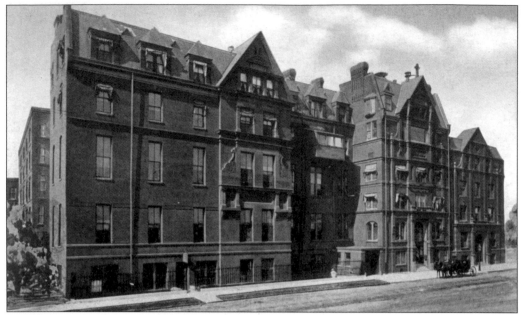

St. Luke's Hospital was started in 1864 by Rev. Clinton Locke, rector of Grace Episcopal Church, with over 50 percent of the patients receiving free care. Treat and Foltz designed the new buildings at 1420–1434 South Indiana Avenue, which opened in 1885. In 1925, these buildings were replaced with a 19-story building designed by Charles S. Frost. It was the tallest hospital building in the world at the time of completion.

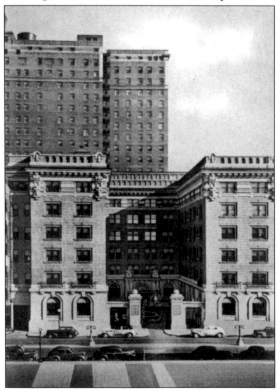

Charles S. Frost designed the George Smith Memorial Building at 1435 South Michigan Avenue for St. Luke's Hospital in 1906. The classical revival detailing clearly expressed its function as a hospital for the wealthy, and it was outfitted like a small luxury hotel. It was one of the first two hospital buildings in Chicago designed exclusively for private patient care. It now contains condominiums and is listed on the National Register of Historic Places.

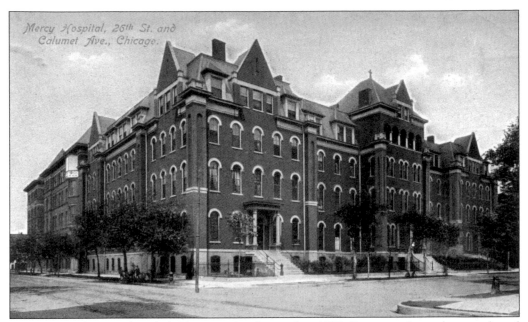

The Sisters of Mercy founded Chicago's first hospital in 1850. Five years later, they purchased land at the northwest corner of Calumet Avenue and Twenty-sixth Street, where these buildings were constructed in 1869. Two additions in the 1890s extended the complex west to Prairie Avenue, forming a natural border for the lower Prairie Avenue residential district. The hospital continues to operate at the same location today in newer buildings.

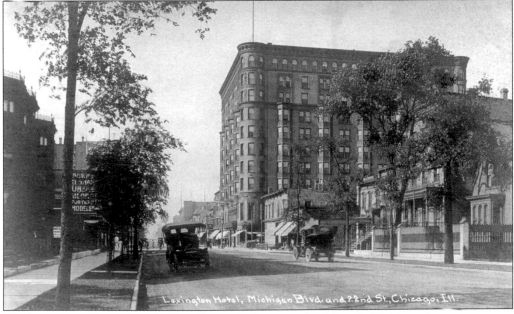

The Lexington Hotel, designed by Clinton J. Warren at 2135 South Michigan Avenue, was one of several hotels built in anticipation of the World's Columbian Exposition. During the 1920s, Al Capone maintained his headquarters in the building, which received widespread attention when Geraldo Rivera open Capone's vault on national television in 1986. Although designated a landmark in 1985, the building was demolished 10 years later in anticipation of redevelopment.

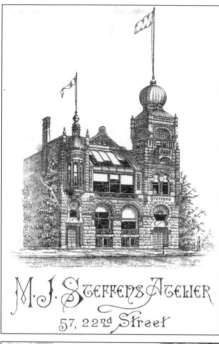

Mathew J. Steffens opened a photographic gallery in the early 1870s on Twenty-second Street, following a brief career as a painter of fancy work for the Pullman Palace Car Company. In 1886, he acquired a Moorish-inspired church building on Twenty-second Street east of Prairie Avenue, which he remodeled into his studio and gallery. Many of Prairie Avenue's leading residents had their portraits taken by Steffens, who retired sometime around 1915.

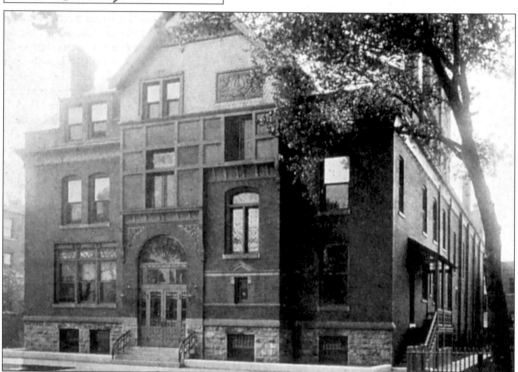

In 1883, Burnham and Root completed this building for the Bournique Dancing Academy on Twenty-third Street east of Prairie Avenue. The Queen Anne structure contained a 60-by-85-foot dance hall that frequently housed debuts and other social events. Harriet Pullman and Josephine Dexter started the South Side dancing class here and it was a right of passage for children in the area. The Bourniques retired in 1918.

Five

PROMINENT RESIDENTS

The outward face of Prairie Avenue was its homes, but the heart of the neighborhood was its residents. Prominent business leaders such as Marshall Field and George M. Pullman loomed large, but many others made extraordinary contributions in business and through their support of philanthropic and cultural causes. The majority of the builders on the street were self-made men, born into humble beginnings in the east. A few, such as John Dean Caton, Fernando Jones, and Silas Cobb, arrived in the 1830s before Chicago was incorporated as a city, but most arrived in the 1850s and 1860s, drawn by the unlimited potential that the city offered. Although many lost their businesses in the Great Chicago Fire, local residents led the rebuilding effort and held positions of authority in the Chicago Relief and Aid Society and other organizations formed to aid the victims of the fire. When the time came for Chicago to host the World's Columbian Exposition, many residents again stepped forward to make significant contributions, which resulted in the *Chicago Tribune* reporting that "without Prairie avenue there would have been no thirty million dollar fair." Numerous philanthropic and cultural organizations were started as a direct result of efforts by local residents, and many others were sustained for decades through generous gifts and endowments. The Anti-Cruelty Society, Orphan Asylum, Home for the Incurables, and many others owed their very existence to the residents of the street. When Daniel Shipman of 1828 South Prairie Avenue died in 1906 and left his entire fortune to charity, the *Chicago Tribune* remarked that "perhaps it is not an unworthy thought that Providence may have decreed that ofttimes marriages are childless in order that worthy charities may be the substantial gainers." The Chicago Symphony Orchestra, Art Institute of Chicago, and the University of Chicago also benefited from decades of devoted service and extraordinary giving. Other residents are remembered today chiefly for the different routes they chose, including Frederic Clay Bartlett and Cecil Clark Davis, who achieved prominence as artists, and Katherine Dexter McCormick and Frances Glessner Lee, who broke away from the traditional roles of women in the early 1900s to forge new paths.

Right Reverend Charles Palmerston Anderson resided at 1612 South Prairie Avenue from 1905 until 1922. In 1900, after serving nine years as rector of Grace Church in Oak Park, he was made coadjutor bishop of the diocese of Chicago and was elected bishop of the diocese in 1905. In 1929, he was elected presiding bishop of the Episcopal Church of the United States but died in January 1930.

William W. Boyington began his career as an architect in 1853, designing many of the most important buildings in Chicago both before and after the Chicago Fire. His most revered works today are the water tower and pumping station, two of the few structures to survive the fire. He built the residence at 2107 South Calumet Avenue and resided there until 1871. He later served two terms as mayor of Highland Park, where he died in 1898.

Daniel H. Burnham looms as one of the great figures in Chicago history, both for his work as supervising architect of the World's Columbian Exposition and as the author of the 1909 *Plan of Chicago.* He moved into the John B. Sherman house at 2100 South Prairie Avenue in 1876 upon his marriage to Sherman's daughter Margaret. This early commission for Burnham and Root led to many others on the street. (Courtesy of the Burnham family.)

Judge John Dean Caton arrived in Chicago in 1833, and as an attorney, he helped organize the village later that year. He served as chief justice of the Supreme Court of Illinois from 1855 to 1864 and made his fortune helping to organize an electric telegraph company that he later sold to Western Union. He made his home at 1900 South Calumet Avenue, where he resided until his death in 1895. (Courtesy of the Newberry Library, Catherine Eddy Beveridge Papers.)

Delia Caton became the second wife of Marshall Field in 1905, less than a year after the death of her first husband, Arthur Caton. She reigned as one of Chicago's society leaders and was among the few women to have her own R. G. Dun credit report. After Field's death, she rarely lived in Chicago and took up residence in the "Pink Palace" in Washington, D. C. (Courtesy of the Newberry Library, Catherine Eddy Beveridge Papers.)

Cecil Clark was born and raised at 2000 South Prairie Avenue, the only daughter of John and Louise Clark. She attended the Art Institute of Chicago and later befriended artist John Singer Sargent, who she called upon for artistic advice. She became an artist of some note, painting portraits of Charles Lindbergh, Lionel Barrymore, and Raold Amundsen. Her *Self Portrait* shown here was completed in 1911. (Courtesy of the Marion Art Center.)

Silas Cobb arrived in Chicago in 1833, and soon after started buying up downtown property that he later sold at huge profits. He was a founding director of the Chicago Gaslight and Coke Company and was a controlling stockholder in several railroads. He built his home at 2101 South Prairie Avenue and later donated $150,000 for the construction of Cobb Hall on the University of Chicago campus. He died in 1900.

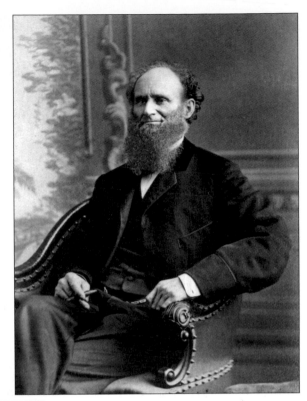

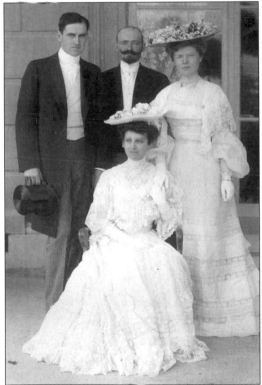

Katherine Dexter (seated), shown here at the time of her marriage to Stanley McCormick (left), was the daughter of attorney Wirt Dexter of 1721 South Prairie Avenue and was among the first female graduates of the Massachusetts Institute of Technology, receiving her degree in biology in 1904. She used her considerable fortune to support the suffrage movement, the League of Women Voters, Planned Parenthood, and the development of the birth control pill. She died in 1967. (Courtesy of the Newberry Library, Catherine Eddy Beveridge Papers.)

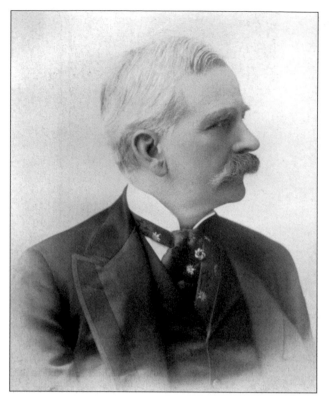

Marshall Field's name is as recognizable today as it was in the 19th century, when he established the firm of Field and Leiter that revolutionized the operation of department stores. His home at 1905 South Prairie Avenue helped establish the preeminence of Prairie Avenue. At his death in 1906, he left a fortune estimated at $120 million, a portion of which was used to construct the Field Museum of Natural History.

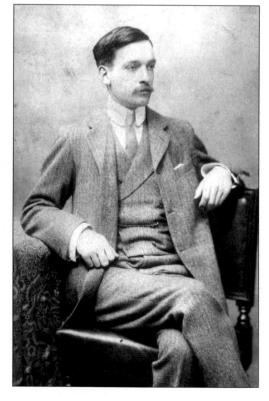

Marshall Field Jr., the only son of Marshall Field, was raised at 1905 South Prairie Avenue and later owned the adjacent home at 1919 South Prairie Avenue. He is remembered today for the controversy surrounding his untimely death from a self-inflicted gunshot wound in 1905 at the age of 38. The official story has remained that it was accidental, but stories of the incident taking place at the infamous Everleigh Club persist to this day.

John J. Glessner arrived in Chicago in 1870, representing his farm machinery firm. In 1902, that firm and four others merged to create International Harvester, creating one of the largest corporations in the world at the time, and he was appointed vice president. He was a longtime trustee of the Chicago Symphony Orchestra and regularly welcomed leading musicians into his famous home at 1800 South Prairie Avenue. He died in 1936.

Glessner's wife, Frances, seen in this unusual multigraph view, was a talented pianist and shared her husband's passion and support for the symphony. For many years, she conducted the Monday Morning Reading Class out of her home, which was comprised of neighborhood women and the wives of University of Chicago professors. She was also a talented silversmith, expert beekeeper, and accomplished needle worker. She died in 1932.

The Glessner's son George was born just six days before the Chicago Fire of 1871. He attended Harvard University and later moved permanently to New Hampshire, taking up residence on the family's summer estate known as the Rocks. He managed the Bethlehem Electric Company and served four distinguished terms in the New Hampshire state legislature between 1913 and his death in 1929.

Fanny Glessner Lee, the Glessner's only daughter, blossomed late in life, when she developed a passion for legal medicine. She endowed the Department of Legal Medicine at Harvard University and later crafted a series of detailed miniature rooms depicting crime scenes, known as the Nutshell Studies of Unexplained Death. They were used as study tools by state police officers from around the country when they attended seminars she organized at Harvard.

Addie Hibbard Gregory holds the distinction of having the longest continuous residence on Prairie Avenue, arriving in 1867 and moving from her longtime home at 1638 South Prairie Avenue in 1944. In 1940, she wrote an account of her life, titled *A Great-Grandmother Remembers*, which chronicles the rise and fall of Prairie Avenue as the background to a record of three generations of her family's life on the avenue. (Courtesy of the Clifford family.)

By 1880, when Turlington Walker Harvey moved into 1702 South Prairie Avenue, he had developed one of the largest lumber operations in the world. In 1890, he organized the Harvey Steel Car Manufacturing Company, for which he founded the company town of Harvey. He served six terms as the president of the Chicago YMCA. This photograph shows him with his children and second wife, Belle. (Courtesy of Bennet B. Harvey.)

Dr. Robert H. Harvey, a son of Turlington Harvey, is shown here in 1903 driving a new automobile outside his home at 2100 South Calumet Avenue. Harvey practiced medicine from 1894 until 1905 and served as physician for the Chicago Orphan Asylum and the Michigan Central Railroad. In 1905, he assumed the position of president of D. B. Fisk and Company, the large wholesale millinery firm started by his grandfather. (Courtesy of Bennet B. Harvey.)

Fernando Jones arrived in Chicago in 1835 and soon became well acquainted with the Native Americans. He assisted them in disbursing the funds for their cession of the lands on which Chicago now stands. He prospered in the title abstract business, and his records proved invaluable after the Chicago Fire when the official records were lost. He died in 1911 at his longtime residence, 1834 South Prairie Avenue.

Katherine Keith was a third-generation Prairie Avenue resident and grew up at 2110 South Prairie Avenue. She is pictured here at the time of her 1916 wedding to architect David Adler. Under her maiden name, she wrote two novels, *The Girl*, published in 1917, and *The Crystal Icicle*, published in 1930. She was killed in an automobile accident that year while traveling in France with her husband. (Courtesy of the David Adler Center Archives, on loan from the David and Katherine Boyd family.)

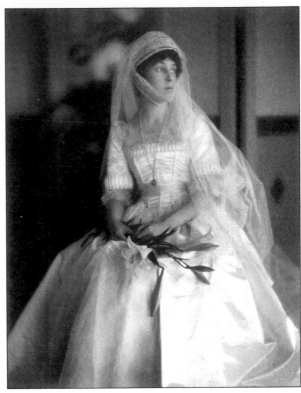

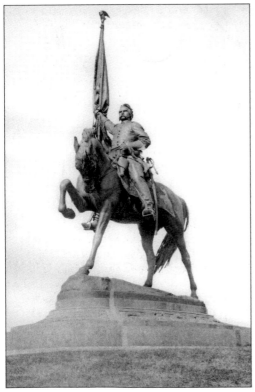

Civil War general John A. Logan, who lived at 2119 South Calumet Avenue, died in 1886 and laid in state in the U.S. Capitol rotunda before his burial in Washington, D.C. Illinois appropriated $50,000 for the erection of a monument, and Augustus St. Gaudens was selected to design the equestrian statue that sits atop a mound in Grant Park at Michigan Avenue and Ninth Street. It was unveiled in July 1897.

In 1896, Frank O. Lowden was united in marriage with George M. Pullman's daughter Florence and at the same time became involved in Republican politics, actively campaigning for William McKinley. From 1906 to 1911, he served in the U.S. House of Representatives, and from 1917 to 1921, he served as governor of Illinois. Upon his marriage, he resided at 217 East Twentieth Street (now Cullerton Street) and later at 1912 South Prairie Avenue.

George M. Pullman made a fortune in the late 1850s by jacking up buildings in downtown Chicago when the city raised the level of the streets by nearly eight feet. In the 1860s, he organized the Pullman Palace Car Company for which he founded the company town of Pullman in 1880. His home at 1729 South Prairie Avenue was one of the largest and most elaborately appointed in the entire city.

At his death in 1915, Norman B. Ream, formerly of 1901 South Prairie Avenue, was ranked as one of the 25 richest men in the United States. His first fortune was made as a livestock and grain commission merchant after his arrival in Chicago in 1871. He subsequently became a director and major stockholder in numerous companies including the Pullman Palace Car Company, First National Bank of Chicago, and several railroads.

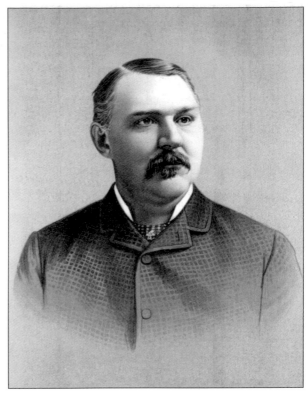

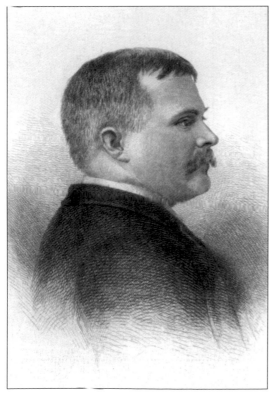

John Wellborn Root was partner in the architectural firm of Burnham and Root. His wife, Mary Louise, was a daughter of James M. Walker of 1720 South Prairie Avenue. He moved into the Walker home upon their marriage in 1880, but his wife died a month later at the age of 21. Root went on to design some of the greatest buildings in 19th-century Chicago before his sudden death in 1891.

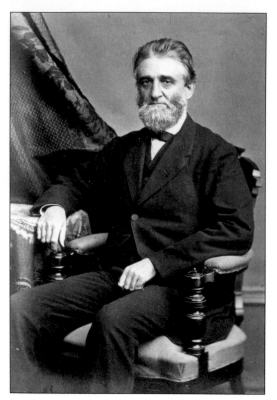

Controversial newspaper editor Wilbur F. Storey leased the Fernando Jones house at 1834 South Prairie Avenue from 1877 until his death. He purchased the *Chicago Times* from Cyrus McCormick at the beginning of the Civil War and used the paper to actively speak out against Pres. Abraham Lincoln and the war. He developed paretic dementia as a result of contracting syphilis and died in his Prairie Avenue home in 1884.

German immigrant Otto Young arrived in the United States in 1859 and came to Chicago in 1872, where he established a huge wholesale jewelry firm. In 1886, he purchased a half-interest in the Fair department store and through the years accumulated vast amounts of downtown real estate. He lived at 2032 South Calumet Avenue and built a palatial summer home at Lake Geneva named Younglands, where he died in 1906. (Courtesy of Linda Williamson.)

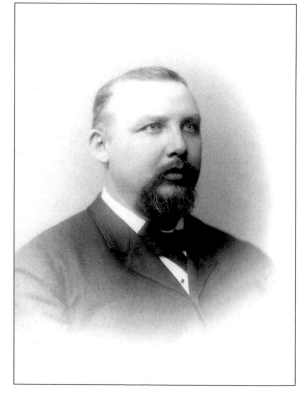

Six

DECLINE AND
TRANSFORMATION

The neighborhood succeeded initially because of its close proximity to downtown, making transportation from home to office quick and efficient. By the early 1900s, this ideal location proved the death knell for the area, as the downtown core expanded and light industry was pushed farther to the south. At the same time, areas such as the Gold Coast, Kenwood, Hyde Park, and the North Shore suburbs were attracting a new generation of Chicago's upper class, and the advent of the automobile made travel easy. The original builders on Prairie Avenue often chose to remain until they died, but the population was aging, and many of the most prominent residents were dead by 1910. It became difficult, if not impossible, to resell the homes for single-family use, so many were converted to business or institutional use, subdivided into furnished rooms, or demolished. Residences were often sold for a fraction of what it had cost to build them 30 or 40 years earlier. New plants for the printing and publishing industry started appearing in the area as early as 1905, targeting Indiana Avenue first, and then Calumet and Prairie Avenues. The automobile industry had completely transformed Michigan Avenue by 1910, with the smooth macadam pavement of the street proving ideal for test driving the newest cars. Chicago did not adopt a comprehensive zoning ordinance until 1923, so there was little residents could do to prevent an industrial plant from being built next door to their home. By the time the ordinance was passed, the entire neighborhood was zoned for industry and manufacturing. The 1920 census reveals that only two dozen original families were still in residence, and an equal number of homes were providing furnished rooms. Many residences were demolished during the Depression to lower property taxes, and vacant lots were converted into parking for the huge number of employees that now worked in the area. The last few original residents of Prairie Avenue either died or moved away by the early 1940s, and only one house continued to function as a single-family residence. The once-glorious street was little more than a memory.

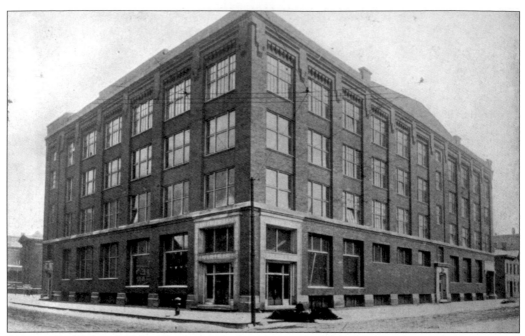

Designed by Hill and Woltersdorf in 1905, the Eastman Kodak building at the northeast corner of Indiana Avenue and Eighteenth Street was the first major industrial building constructed in the neighborhood. In 1928, the west 34 feet of the building were demolished when Indiana Avenue was widened. Eastman Kodak constructed another large building in the art moderne style along the 1700 block of Prairie Avenue in 1939, designed by Schmidt, Garden, and Erickson.

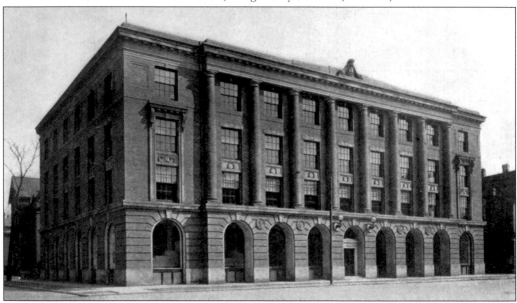

This building, for the publishing firm of Ginn and Company, was built in 1907 at 2301 South Prairie Avenue. Howard Van Doren Shaw utilized finely detailed classical revival features to help the structure blend with its residential neighborhood. Later occupied by the Platt Luggage Company, the building was twice rescued from demolition. In 2004, the facade was rebuilt at Cermak Road and King Drive to conceal a power plant cooling facility.

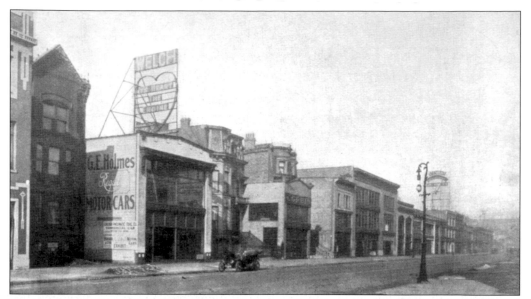

The transformation of Michigan Avenue between Twelfth Street (now Roosevelt Road) and Twenty-sixth Street into Chicago's "motor row" began in 1902. By the time this image looking north from Sixteenth Street was taken in 1910, a majority of the residences had been replaced with two- and three-story automobile showrooms. The 56 surviving structures on the street were landmarked as the Motor Row Historic District in 2000.

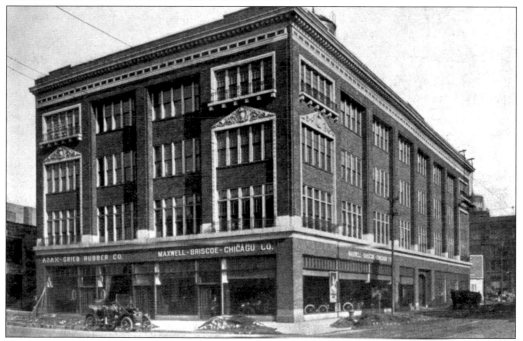

This showroom, leased to the Maxwell-Briscoe Automobile Company, was built in 1909 by the heirs of the William B. Howard estate, whose family home had stood on the site. The building was designed by Ernest Walker, who had previously spent several years working in the architectural offices of Henry Ives Cobb. Located at 1737 South Michigan Avenue, the structure was restored by McHugh Construction Company for use as their headquarters.

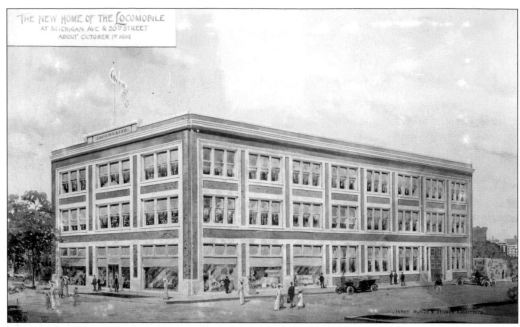

The firm of Jenney, Mundie and Jensen designed this attractive showroom in red brick and white terra-cotta for the Locomobile Automobile Company at 2000 South Michigan Avenue in 1909. In recent years, the building has been redeveloped into condominiums known as Locomobile Lofts. The Locomobile name can still be seen in terra-cotta set into the parapet along the Michigan Avenue facade. (Courtesy of Jensen and Halstead Ltd.)

Buick constructed one of the few automobile-related buildings east of Michigan Avenue in 1909, and utilized this four-story structure at 2035 South Calumet Avenue for wholesale, warehousing, and offices. Their retail showroom at 1452 South Michigan Avenue was closed in 1912, at which time retail operations were also brought over to the site. The building sat on land leased by the Newberry Library for investment. (Courtesy of Bennet B. Harvey.)

The first loft building on Prairie Avenue replaced a pair of row houses at 1609–1611 South Prairie Avenue in 1910. The four-story building, seen at far left soon after completion, cost $22,000 to construct and was built and owned by E. T. Cade. An automobile repair shop operated out of the first floor, with a windshield manufacturer located above. The building was razed in 1942. (Courtesy of the Chicago History Museum.)

By 1920, an unusual automobile-related business was operating out of the former residence of James R. Walker at 1726 South Prairie Avenue. The Tourist Camp Body Company designed and manufactured the "kitchenette apartment on wheels," a forerunner to modern recreational vehicles, or RVs. Ironically they used Pullman palace coaches and were located directly across the street from the site of the Pullman mansion.

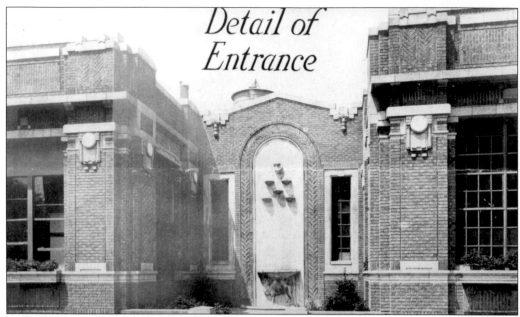

Detail of Entrance

The residence of Samuel Allerton at 1936 South Prairie Avenue, with its 193 feet of frontage, was sold soon after his death in 1914 to Sol Goldberg, who commissioned architect Alfred Alschuler to design a large, one-story plant for his Hump Hair Pin Manufacturing Company. Alschuler also designed a large addition to the north in 1939 following the demolition of 1912 South Prairie Avenue. The factory was razed in 1999 for a townhouse development.

The company, which adopted the camel for its trademark, manufactured many types of hair products but was known for its patented hump hairpin, which featured a small projecting piece at the top containing a hump that helped secure it in place. During World War II, production was suspended so that bombsite parts could be manufactured in the plant. This image shows a package of hair pins produced about 1920.

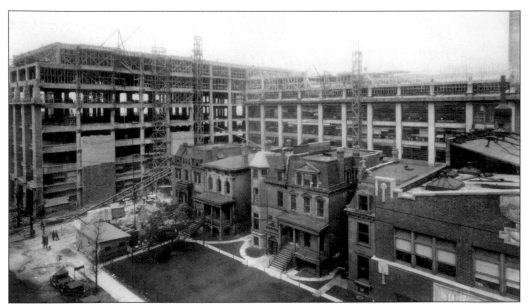

The largest plant built in the neighborhood was constructed for R. R. Donnelley and Sons beginning in 1912. Donnelley acquired the entire east side of the 2100 block of Calumet Avenue for the building, designed by Howard Van Doren Shaw in the Gothic Revival style. This view shows construction on the east half of the building in 1917 and vividly portrays the transformation of the neighborhood underway at the time. (Courtesy of the Special Collections Research Center, University of Chicago Library.)

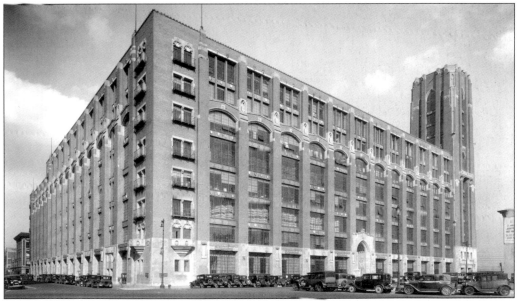

The south and west portions of the Donnelley plant were completed by Charles Z. Klauder, following Shaw's death in 1926. The detailing of the exterior is quite extraordinary and features 500 terra-cotta shields depicting historic printers' marks. Donnelley moved out of the building in 1994, and it was converted into the Lakeside Technology Center, housing huge computer servers. The building was landmarked in 2003. (Courtesy of the Special Collections Research Center, University of Chicago Library.)

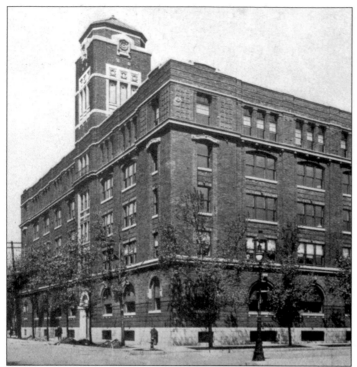

The American Book Company built directly west of R. R. Donnelley and Sons in 1912 at 320–334 East Twentieth Street (now Cermak Road). Designed by Nelson Max Dunning, the complex was acquired by Donnelley in 1938, which then moved its printing offices for *Time* and *Life* magazines here. A series of additions in the 1940s and 1950s to accommodate the printing of the Sears catalog eventually covered the entire block.

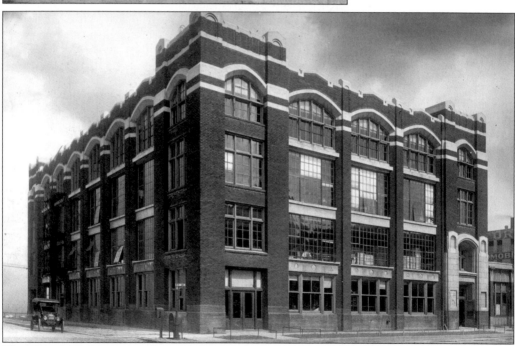

The firm of Jenney, Mundie and Jensen designed this four-story loft building in 1913 at 2001 South Calumet Avenue. The property was owned by the Newberry Library and was leased for a number of years to the printing firm Rogers and Company. In 2000, the building was redeveloped into 59 lofts, at which time three stories were added. Weese, Langley and Weese designed the condominium conversion. (Courtesy of Jensen and Halstead Ltd.)

The Columbian Colortype Company built its previous plant at 2141 South Calumet Avenue in 1909. In 1920, it acquired the home of the late Otto Young at 2032 South Calumet Avenue and hired Alfred Alschuler to design this larger facility. During the 1960s, the building was acquired by Chess Records, who moved here from 2120 South Michigan Avenue. In 2007, it was redeveloped into condominiums known as Chess Lofts. (Courtesy of American Terra Cotta Company Records, Northwest Architectural Archives, University of Minnesota Libraries, Minneapolis, Minnesota.)

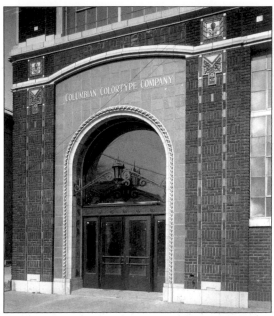

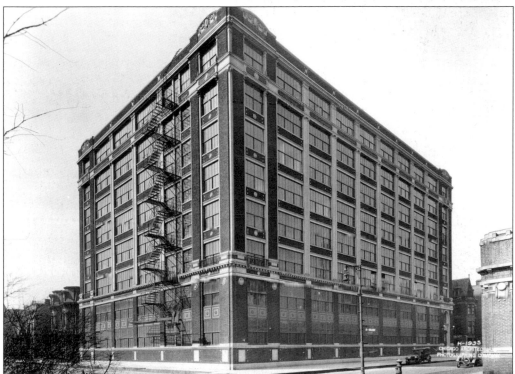

Alfred Alschuler also designed this eight-story loft building for the Atwell Printing Company at the southwest corner of Prairie Avenue and Twentieth Street (now Cullerton Street) in 1922. It replaced the homes of John Clark and William Grey. The Atwell company occupied the first three floors and rented out the remaining space to other publishers. It has since been converted into residential lofts. (Courtesy of American Terra Cotta Company Records, Northwest Architectural Archives, University of Minnesota Libraries, Minneapolis, Minnesota.)

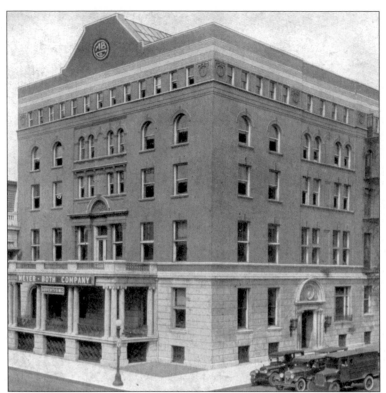

The venerable old Calumet Club at the northeast corner of Michigan Avenue and Twentieth Street closed its doors in 1914, and within a few years, the building was converted into the offices and studios of the Meyer-Both Company, which added large, skylit studio spaces on the top level. The company billed itself as the largest commercial art organization in the world, employing over 100 artists.

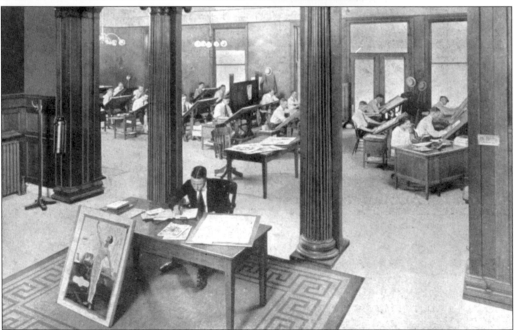

This view of the second-floor great hall shows Meyer-Both's general art room beyond the imposing columned entryway. The space had originally functioned as the Calumet Club's card and meeting room. Meyer-Both created more than 15,000 pieces of artwork annually for more than 1,500 newspapers and 3,000 retail stores.

The Century of Progress World's Fair of 1933 and 1934 was held directly east of the neighborhood on landfill created during the 1920s. This bridge at Calumet Avenue and Eighteenth Street was constructed over the Illinois Central Railroad tracks to provide easy access to the fairgrounds from the many vacant lots converted into visitor parking along Prairie and Calumet Avenues. The bridge was replaced in 2004.

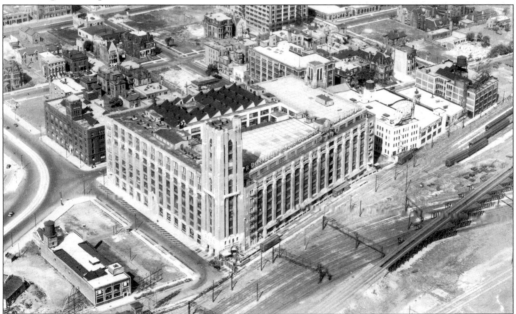

This aerial view of the neighborhood was taken in September 1935 looking northwest, with the R. R. Donnelley and Sons Calumet Avenue plant in the foreground. It provides an excellent overview of the area at the time, with a mix of original residences set among vacant lots and dwarfed by the numerous large buildings for the printing and publishing industry. (Courtesy of the Special Collections Research Center, University of Chicago Library.)

In 1949, novelist Arthur Meeker, who grew up at 1815 South Prairie Avenue in the early 1900s, published a fictional novel of life on the street, titled *Prairie Avenue*. Although the characters and events were fictional, it was based on his actual experiences and stories he was told by his parents. The novel was serialized in the *Chicago Tribune*, which brought about a sudden interest in the long-forgotten street.

This view of Prairie Avenue looking south at Eighteenth Street in 1951 is what newspaper reporters found when they went searching for Meeker's *Prairie Avenue*. (See page 2 for the same view taken 50 years earlier). A *Chicago Tribune* article said that the surviving mansions were "hollow shells emptied of the gay luxurious life they once sheltered—grotesque, disquieting memorials amid the tenements, small workshops, and bare fields of today." (Courtesy of the Chicago History Museum.)

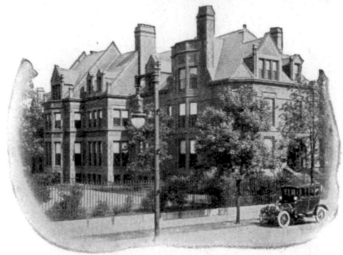

Drug and Liquor Habits
QUICKLY AND PAINLESSLY CURED

(Former Mansion, Marshall Field, Jr.)

GATLIN INSTITUTE, 1919 Prairie Avenue, CHICAGO

The houses that did survive were adapted for various uses. One of the first to be converted was the Marshall Field Jr. residence at 1919 South Prairie Avenue, which was acquired by Dr. Milton Pine in 1909 for his Gatlin Institute that treated drug and alcohol addiction. It later housed the Monterey Convalescent Home, which closed in 1977. After that, the house sat empty and deteriorating for the next 25 years.

The Marshall Field home at 1905 South Prairie Avenue was donated to the Association of Arts and Industries in 1936, which opened its New Bauhaus school there in November 1937. The school was led by Laszlo Moholy-Nagy, standing at the right on the renovated spiral staircase with Walter Gropius, founder of the Bauhaus school in Germany. The school later became the Institute of Design at the Illinois Institute of Technology. (Copyright Bettman/CORBIS.)

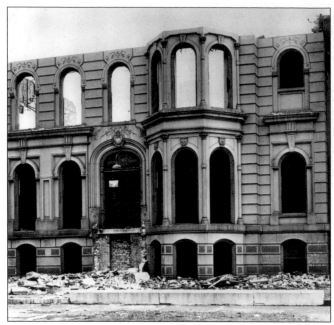

Belle Armour abandoned 2115 South Prairie Avenue in 1921, giving it rent-free to the chauffeur who had served her for over 30 years. After her death, the house was sold and converted into furnished rooms. It is seen here during its demolition in December 1937. R. R. Donnelley and Sons purchased the entire east side of the 2100 block of Prairie Avenue in the 1930s to expand its facility.

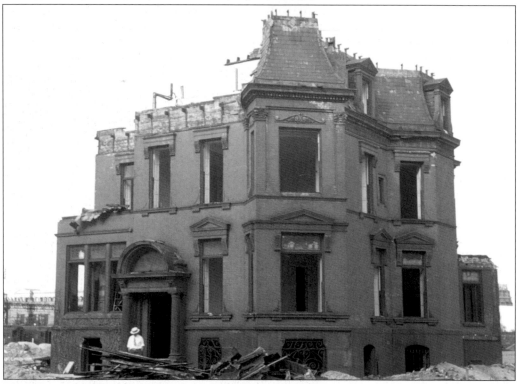

The house at 1709 South Prairie Avenue was designed in 1883 by Burnham and Root for clothing manufacturer Palmer V. Kellogg, who died the week his family moved in. For many years, it was the home of Philo Adams Otis, a prominent hymn composer. He and his wife, Alice, were among the last residents to leave Prairie Avenue. The house is seen here during its demolition in August 1941. (Courtesy of the Indiana University Archives.)

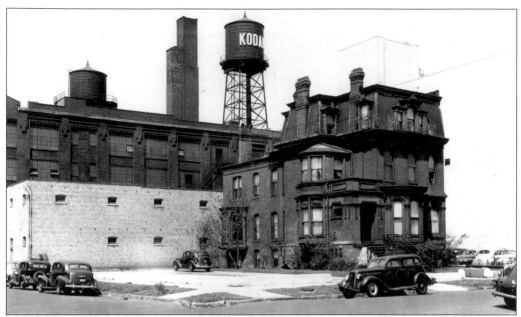

The elegant Second Empire–style house at 1730 South Prairie Avenue was built for insurance man A. A. Dewey. In 1887, it was acquired by real estate dealer Joseph E. Otis, whose family remained for many years. It was eventually used as a boardinghouse and is seen here shortly before its demolition in 1945 in the shadow of the Eastman Kodak plant, which was soon to expand along the 1700 block of Prairie Avenue. (Courtesy of the Prairie District Lofts.)

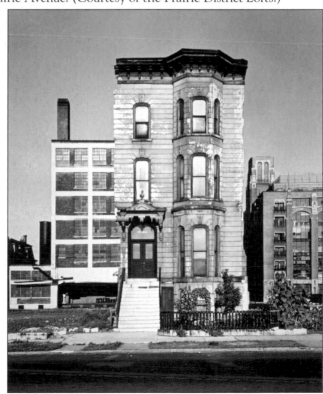

This classic 1946 image by noted photographer Walker Evans captures the home of the Frederick R. Otis family at 2033 South Prairie Avenue. Three unmarried Otis children remained in the house until the 1930s, making them among the last residents of the street. It was originally the middle building in a grouping of three row houses constructed in 1869 (see page 17). (Walker Evans, *2033 Prairie Avenue, Chicago*, 1946, gelatin silver print, 26.3 by 21.7 centimeters, gift of David C. and Sarajean Ruttenberg, 1991.1475, the Art Institute of Chicago.)

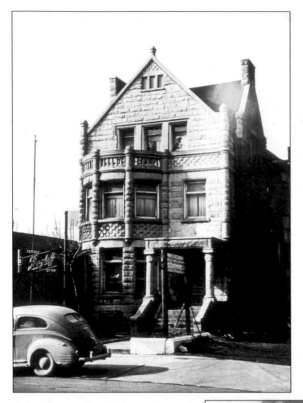

The site at 2018 South Prairie Avenue was previously occupied by the home of Josiah Lombard, a real estate developer and one of the founders of the village of Lombard. In 1887, architects Edbrooke and Burnham designed this stately Romanesque-style residence for Lavinia Herrick, a widow. In 1927, the house was sold to Oreste Montagnole, who operated Monti's Restaurant out of the building for many years. It was razed about 1963. (Courtesy of the Chicago History Museum.)

Henry C. Durand, head of the oldest wholesale grocery house in Chicago, built this house at 2001 South Prairie Avenue in the late 1860s. Originally it was one of a pair of row houses. Durand later moved to Lake Forest, where he provided funding for four buildings on the Lake Forest College campus. The house was divided into small apartments and is seen here in 1957, shortly before it was demolished. (Courtesy of Jack Simmerling.)

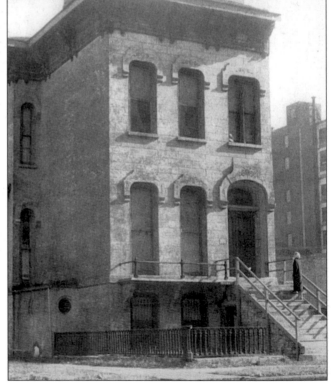

This 1868 home at 1612 South Prairie Avenue had previously served as the residence of the Studebaker family and the Episcopal bishop of Chicago. It is seen here in 1959 shortly before its demolition. The stacks of old furniture in front of the house clearly convey its later use as apartments, although the facade itself is still largely intact. It was the last house standing on Prairie Avenue north of Eighteenth Street. (Courtesy of John Vinci.)

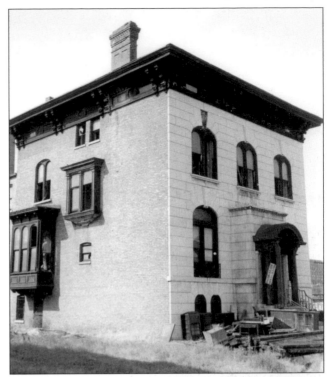

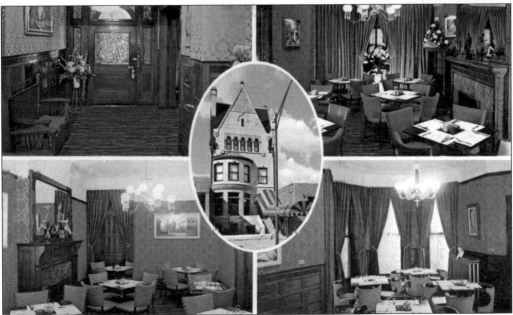

Cobb and Frost designed the elegant stone house at 2110 South Prairie Avenue in 1888 for Harriet P. Rees, a widow. It contained one of the first elevators in a private residence. For many years, it was the residence of Edson Keith Jr., who had grown up at 1906 South Prairie Avenue. By 1970, the house had been converted into the Prairie House Café, seen here, which operated until 1975. The house was listed on the National Register of Historic Places in 2007. (Courtesy of Jack Simmerling.)

This oil painting by African American artist Irene Clark vividly portrays the changing perception of the street and no doubt depicts a house on lower Prairie Avenue, as property owners north of Twenty-second Street (Cermak Road) adopted a "colored restriction agreement" in 1940, preventing occupancy or ownership by African Americans. (Irene Clark, *A Mansion at Prairie Avenue*, c. 1955, oil on plywood, 36.2 by 33 centimeters, Walter M. Campana Memorial Prize Fund, 2003.40, the Art Institute of Chicago.)

This five-story building on Eighteenth Street just west of Indiana Avenue was built in 1885 as a fashionable apartment hotel. By the time of this 1950 photograph, the building and the connecting three-story apartment house facing Indiana Avenue (visible at far left) were occupied by more than 500 individuals, with as many as six people sharing a single room. The city declared it one of the worst slum buildings in Chicago. (Courtesy of the Chicago History Museum.)

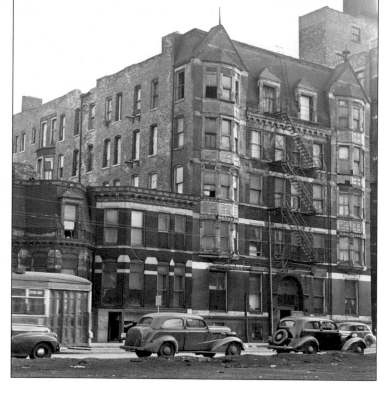

Seven

PRESERVATION
AND REBIRTH

The glorious legacy of Prairie Avenue was largely forgotten until the Glessner house at 1800 South Prairie Avenue was put up for sale in 1965. The architectural community realized the importance of the building and was determined to save it from demolition. In 1966, the Chicago School of Architecture Foundation was formed and by September had raised the funds to purchase the house. Within two years, however, three neighboring houses were demolished. Interest was generated in creating a conservation area around the Glessner house to preserve the remaining houses and maintain the surviving 19th century context in which it was built. A Prairie Avenue District Committee was formed, and in 1973, the mayor announced that the city was moving forward with plans to create its first historic district. The Henry B. Clarke house, now Chicago's oldest building, was purchased by the city and moved back to the area to be restored and opened as a house museum. The 1800 block of Prairie Avenue was returned to its 1890s appearance and closed off to vehicular traffic. Work was completed in 1978, and the historic district was formally designated the following year.

In 1989, 69 acres of abandoned railroad yards north of the neighborhood were purchased for a huge residential development to be known as Central Station. The project proved immensely popular and redevelopment began working its way into the historic area. In 1993, the Eastman Kodak Company building at 1727 South Indiana Avenue was converted into residential rental units known as Prairie District Lofts, and two years later, the East Side Lofts at 1601 South Indiana Avenue became the first condominium loft conversion in the area. The year 1999 marked the first new residential construction on Prairie Avenue in 95 years, when a townhouse complex replaced the Hump Hairpin factory. Since that time, virtually every loft building has been converted into residential lofts, several new developments, including townhouses and condominium towers have been built, and the neighborhood has experienced a growth that resulted in *Chicago* magazine awarding the area the distinction of being the hottest real estate market in the country in 2007.

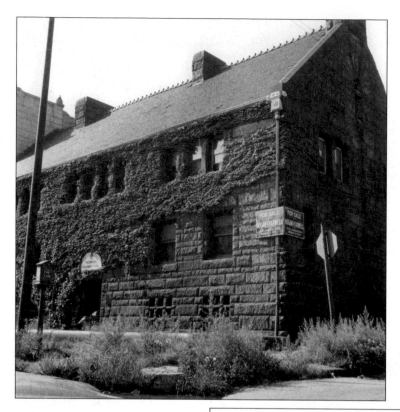

For sale signs were placed on the Glessner house at 1800 South Prairie Avenue in 1965. In September of the following year, the house was sold for $35,000 to the Chicago School of Architecture Foundation, which had been formed to coordinate efforts to purchase and maintain the house. Photographer Richard Nickel, who played an important role in the emerging preservation movement in Chicago during the 1960s, took this image. (Photograph by Richard Nickel, courtesy of the Richard Nickel Committee, Chicago, Illinois.)

The house at 1815 South Prairie Avenue (see page 35) was sold to Arthur Meeker in 1902. Meeker hired Arthur Heun to make major design changes, which included moving the main entrance down to ground level. In 1914, the house was sold to publishers D. C. Heath and Company, who, in turn, sold it to R. R. Donnelley and Sons in 1967. It was razed later that year. (Courtesy of John Vinci.)

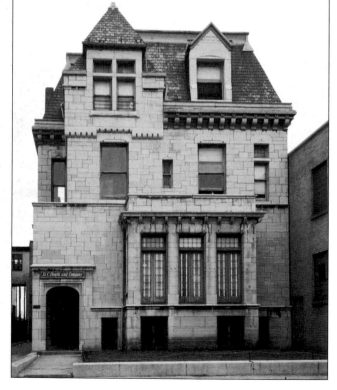

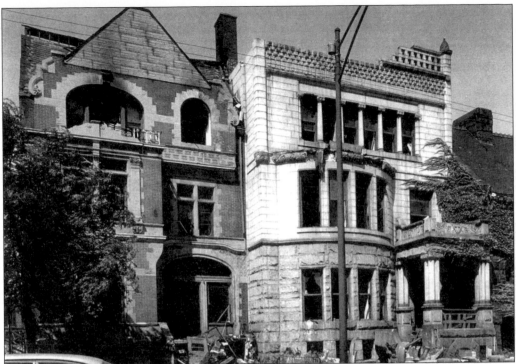

The two houses immediately south of the Glessner house at 1812 and 1808 South Prairie Avenue had functioned as offices and furnished rooms for many years. R. R. Donnelley and Sons razed them in 1968 after a damaging fire. The north wall of 1808 South Prairie Avenue was left standing as it had been designed to function as the south wall of the adjacent Glessner house courtyard. (Photograph by Richard Nickel, courtesy of the Richard Nickel Committee, Chicago, Illinois.)

In September 1974, Gov. Dan Walker provided $350,000 in funding through the State of Illinois Open Space Land Acquisition Program that was matched by $150,000 from the City of Chicago. The funds were used to acquire numerous vacant lots along Prairie and Indiana Avenues and several buildings at Indiana Avenue and Eighteenth Street in order to create the Prairie Avenue Historic District.

The vacant lots and former parking areas along Prairie and Indiana Avenues were cleared of debris and several structures in the late 1970s and planted with grass to provide this pleasant green space, originally intended to become an architectural fragment park. Decorative wrought iron fencing in various designs along the Prairie Avenue side of the park demarcated each of the six properties that originally stood south of the Glessner house.

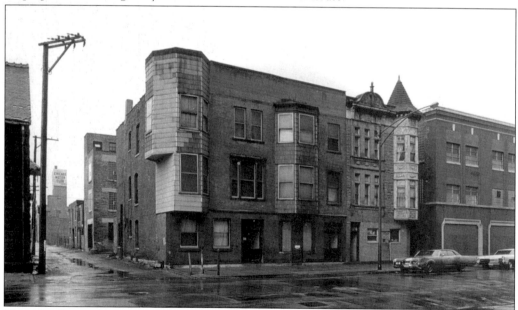

Three brick townhouses, located immediately west of the Glessner house on Eighteenth Street, were purchased using state and city funds in the 1970s. They had been built around 1870 and significantly rebuilt in the early 1890s. The buildings were all severely deteriorated, so the decision was made to have them razed and replaced with a brick plaza area to serve as a gateway into the park area to the south. (Photograph by Richard Nickel, courtesy of the Richard Nickel Committee, Chicago, Illinois.)

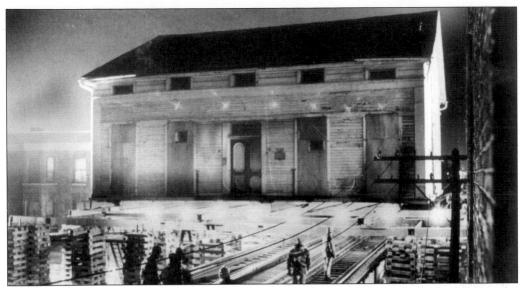

A key component in the creation of the Prairie Avenue Historic District involved relocating the Clarke house from its second location at 4526 South Wabash Avenue to a site in the newly created park. This view shows the house being moved across the elevated tracks at Forty-fourth Street on December 4, 1977, onto temporary jacks that had frozen. The house could not be lowered down to the ground for two weeks. (Photograph by Robert Black, courtesy of the Chicago Sun-Times.)

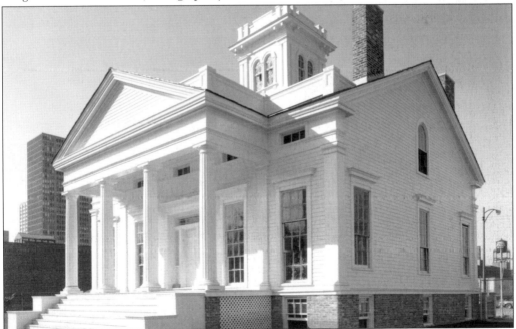

The Clarke house was moved to a site in the 1800 block of Indiana Avenue, approximately three blocks from where it had originally been constructed in 1836 (see page 12). The house was restored to the period of the Clarke family occupancy and fully furnished by the National Society of the Colonial Dames of America in the State of Illinois. It opened as a house museum in 1982 and underwent a second major restoration in 2004. (Photograph by Robert Thall, courtesy of the Clarke House Museum.)

In May 1977, restoration of the streetscape in the 1800 block of Prairie Avenue was undertaken by the Chicago Department of Public Works. The work included replicating the original cobblestone gutters and granite curbs, installing authentic 1890s streetlamps, and replacing the concrete sidewalks with limestone. The district was officially opened in September 1978 and was designated a landmark district the following year.

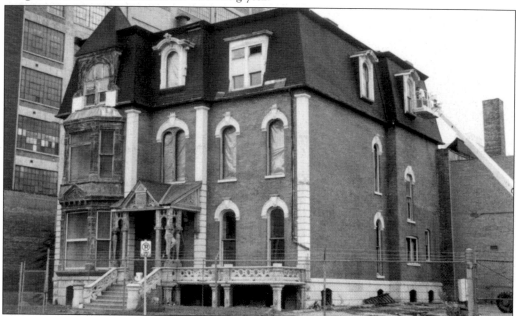

The house at 2018 South Calumet Avenue was the last surviving residence on that street and had been sitting vacant since the mid-1980s when the Murphy Butter and Egg Company moved out. In the summer of 1997, it was rescued from demolition and purchased for $10,000 by a couple who then undertook a massive 18-month restoration. It opened as a boutique hotel known as the Wheeler Mansion in October 1999.

On October 27, 1997, First Lady Hillary Clinton, who celebrated her 50th birthday in Chicago the previous day, came to Prairie Avenue for the groundbreaking of the Hillary Rodham Clinton Women's Park and Gardens of Chicago. The inspiration for the park came from Lois Weisberg, commissioner of the Chicago Department of Cultural Affairs, who desired a park that would honor important Chicago women throughout history.

Two million dollars in tax increment financing (TIF) monies were used by 2000 to transform the green space into a world-class garden under the guidance of landscape designer Mimi McKay. Original paving bricks from the historic alley that originally bisected the space were used to edge a series of gravel paths. The name was changed to the Chicago Women's Park and Gardens to more clearly portray its mission of honoring all Chicago women. (Courtesy of the Clarke House Museum.)

In 1989, Fogelson Properties paid $18 million to purchase 69 acres of prime undeveloped lakefront property south of Roosevelt Road from the Illinois Central Railroad for the creation of a residential development to be known as Central Station. Construction began in 1991, and two years later, Mayor Richard M. Daley relocated to the area. Here townhouses are under construction in 1999 along the newly created 1400 block of Prairie Avenue.

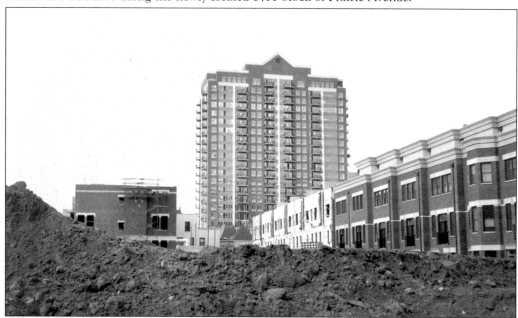

By the late 1990s, the creation of Central Station had spurred residential redevelopment as far south as Cullerton Street. This 2003 view, looking north along the east side of the 1800 block of Prairie Avenue, shows the Prairie Tower nearing completion on the site of the former Pullman family residence. In the foreground, work proceeds on a complex of 37 townhouses known as the Commonwealth on Prairie Avenue (Phase III).

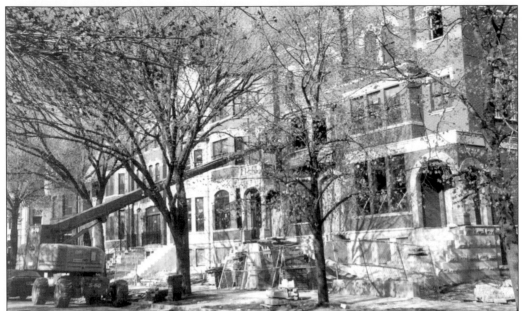

This view, taken in April 2004, shows construction on the 17 units in the Commonwealth on Prairie Avenue development that front directly on the street. The appearance and massing of the units were subject to review by the Commission on Chicago Landmarks, as the development fell within the borders of the historic district. The units were the first to break the $1 million price barrier in the area.

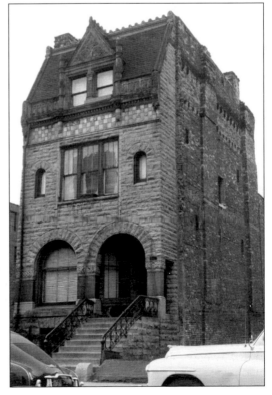

As redevelopment spread through the neighborhood, additional structures outside of the formal boundaries of the historic district were lost. The house at 1904 South Indiana Avenue was the last surviving residence on that street and had been designed as one of a pair in 1887 by Joseph Lyman Silsbee. It was razed in 1999 as part of the Bank Note Place development at the northwest corner of Indiana Avenue and Cullerton Street. (Courtesy of the Chicago History Museum.)

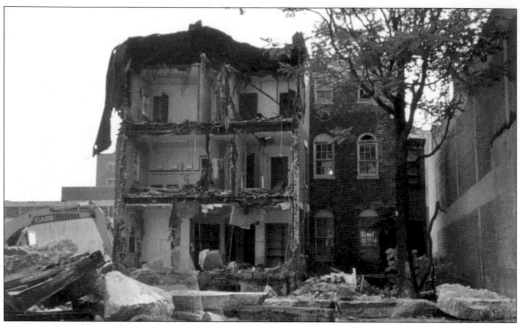

The house at 2126 South Prairie Avenue served as the Chicago office of World Book for many years, and in the 1970s, it housed a University of Chicago methadone clinic. After sitting empty for several years and being judged unsafe by the City of Chicago, it was demolished in 2002, although there were no redevelopment plans for the site. Here demolition proceeds on the rear section that dated to the late 1860s.

Occasionally, redevelopment uncovers a long-forgotten part of the neighborhood's past. Here blocks of Connecticut brownstone that had originally been part of the Philander C. Hanford house at 2008 South Calumet Avenue are unearthed during excavation of the site in 1999 for the foundations of a townhouse development. The stone, for which the original owner paid a small fortune, was shipped off to a landfill. (Courtesy of Jack Simmerling.)

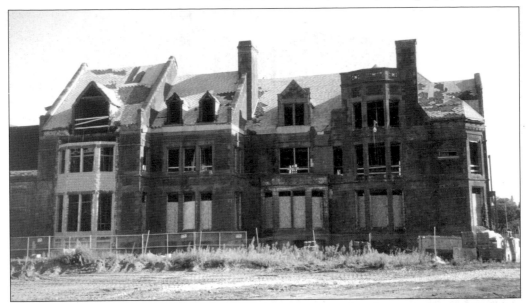

The Marshall Field Jr. house at 1919 South Prairie Avenue sat largely vacant since the nursing home that occupied the building closed in 1977. Several plans for redevelopment were proposed during the intervening years, but none proved successful. In 2003, a developer began the massive project of restoring the exterior and renovating the interior into six luxury condominium units, the first of which was ready for occupancy in 2007.

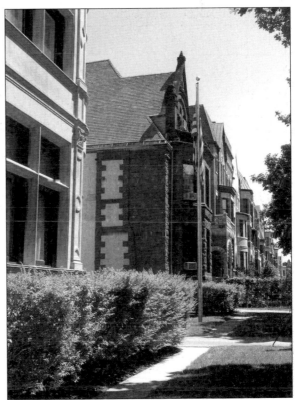

A walk through the neighborhood today is a fascinating journey through time—from the restored Henry B. Clarke house of 1836 to new condominium high rises and from historic 19th-century mansions to converted 20th-century loft buildings. Here the historic Kimball and Coleman houses stand side by side with new luxury townhomes along the 1800 block of Prairie Avenue, creating a virtual museum of urban development and change.

List of Residents
in 1893

The following residents of Prairie and Calumet Avenues were listed in the *Chicago Blue Book* at the time of the World's Columbian Exposition of 1893:

Prairie Avenue

1600: Mr. and Mrs. John G. Shortall
1608: Mr. and Mrs. Henry L. Frank
1612: Mr. and Mrs. Peter E. Studebaker
1615: Mr. and Mrs. Thomas D. Rhodes
1616: Mr. and Mrs. William R. Stirling
1619: Mr. and Mrs. J. Foster Rhodes
1620: Mr. Robert H. Law
1621: Mr. and Mrs. John H. Hamline
1623: Mr. and Mrs. Granger Farwell
1625: Mr. and Mrs. Hugh J. McBirney
1626: Mr. and Mrs. Abraham Longini
1628: Mr. and Mrs. Morris Einstein
1630: Mr. and Mrs. Peter Brust
1634: Mr. and Mrs. Erastus Foote
1636: Mr. and Mrs. H. Morris Johnston
1637: Mr. and Mrs. Jesse Spalding
1638: Mr. and Mrs. Robert B. Gregory
1701: Mr. and Mrs. William G. Hibbard
1702: Mr. and Mrs. Turlington W. Harvey
1709: Mrs. Palmer V. Kellogg
1712: Mr. Albert Sturges
1720: Mrs. James M. Walker

1721: Mrs. Wirt Dexter
1726: Mr. and Mrs. James R. Walker
1729: Mr. and Mrs. George M. Pullman
1730: Mr. and Mrs. Joseph E. Otis
1736: Mr. and Mrs. Hugh J. McBirney
1800: Mr. and Mrs. John J. Glessner
1801: Mr. and Mrs. William W. Kimball
1808: Mr. and Mrs. O. R. Keith
1811: Mr. and Mrs. William B. Keep
1812: Mr. and Mrs. George H. Wheeler
1815: vacant
1816: Mr. and Mrs. Charles M. Henderson
1823: Mr. and Mrs. Thomas Dent
1824: Mr. and Mrs. Charles Schwartz
1827: Mr. and Mrs. John W. Doane
1828: Mr. and Mrs. Daniel B. Shipman
1834: Mr. and Mrs. Fernando Jones
1900: Mr. and Mrs. Elbridge G. Keith
1901: Mr. and Mrs. Norman B. Ream
1905: Mr. and Mrs. Marshall Field
1906: Mr. and Mrs. Edson Keith
1912: Mr. and Mrs. Mosher T. Greene

1919: Mr. and Mrs. Marshall Field Jr.
1923: Mrs. Charles P. Kellogg
1936: Mr. and Mrs. Samuel W. Allerton
1945: Mrs. Henry Corwith
2000: Mr. and Mrs. John M. Clark
2001: Dr. and Mrs. John W. Streeter
2003: Mr. and Mrs. George F. Bissell
2009: Mrs. Max A. Meyer
2010: Mr. and Mrs. William L. Grey
2011: Mrs. Wilbur F. Storey
2013: Mr. and Mrs. William H. Reid
2017: Mrs. William Armour
2017: Mr. Silas B. Cobb
2018: Mrs. Elijah W. Herrick
2021: Mr. and Mrs. James L. High
2026: Mrs. Levi Rosenfeld
2027: Mr. and Mrs. William B. Walker

2031: Mr. and Mrs. Samuel A. Tolman
2033: Mr. and Mrs. Frederick R. Otis
2035: Mrs. Horatio O. Stone
2036: Mr. Ebenezer Buckingham
2100: Mr. and Mrs. John B. Sherman
2101: Mr. and Mrs. Eugene S. Pike
2108: Mrs. Miner T. Ames
2109: Mr. and Mrs. Robert W. Roloson
2110: vacant
2112: Mr. and Mrs. Max M. Rothschild
2115: Mr. and Mrs. Philip D. Armour
2120: Mr. and Mrs. Frank S. Gorton
2123: Mr. Thomas M. Avery
2125: Mr. and Mrs. Charles H. Wheeler
2126: Mr. and Mrs. Charles D. Hamill
2130: Mr. Thomas Murdoch
2140: Mr. and Mrs. Byron L. Smith

CALUMET AVENUE

1830: Dr. and Mrs. William E. Casselberry
1832: Mr. and Mrs. John Buckingham
1836: Mr. and Mrs. Norman Williams
1840: Mr. Charles E. Fargo
1900: Judge and Mrs. John D. Caton
1910: Mr. and Mrs. Arthur J. Caton
1921: Mr. and Mrs. George P. Beardsley
1922: Mr. and Mrs. Henry Dibblee
1928: Mr. and Mrs. H. N. Greene
1929: Mrs. L. A. Frankelyn
1931: Mr. and Mrs. James G. Goodrich
1932: Mr. and Mrs. J. T. Chumasero
2000: Mr. and Mrs. Henry Crawford
2004: Mr. and Mrs. William H. Mitchell
2008: Mr. and Mrs. Philander C. Hanford
2016: Mr. and Mrs. Charles H. Starkweather
2018: Mr. and Mrs. Joseph A. Kohn

2032: Mr. and Mrs. Otto Young
2100: Mrs. David B. Fisk
2101: Mrs. Moses Gunn
2106: Mr. and Mrs. Alpheus C. Badger
2107: Mr. and Mrs. Arthur B. Meeker
2114: Mr. and Mrs. John B. Drake
2115: Mr. and Mrs. John A. Hamlin
2119: Mr. and Mrs. George M. Moulton
2124: Mr. and Mrs. Theodore A. Shaw
2125: Mr. and Mrs. John A. Markley
2128: Mr. and Mrs. John A. Davidson
2129: Mr. and Mrs. William E. Kelley
2131: Mr. and Mrs. John Alling
2133: Mr. and Mrs. John R. Walsh
2140: Mrs. Daniel A. Jones
2141: Mr. and Mrs. D. V. Purington

ACROSS AMERICA, PEOPLE ARE DISCOVERING SOMETHING WONDERFUL. THEIR HERITAGE.

Arcadia Publishing is the leading local history publisher in the United States. With more than 3,000 titles in print and hundreds of new titles released every year, Arcadia has extensive specialized experience chronicling the history of communities and celebrating America's hidden stories, bringing to life the people, places, and events from the past. To discover the history of other communities across the nation, please visit:

www.arcadiapublishing.com

Customized search tools allow you to find regional history books about the town where you grew up, the cities where your friends and family live, the town where your parents met, or even that retirement spot you've been dreaming about.